PHOTOGRAPHIC VIEWS OF
SHERMAN'S CAMPAIGN

George N. Barnard

With a New Preface by
Beaumont Newhall

DOVER PUBLICATIONS, INC.
NEW YORK

Published in Canada by General Publishing Company, Ltd., 30 Lesmill Road, Don Mills, Toronto, Ontario.
Published in the United Kingdom by Constable and Company, Ltd.

This Dover edition, first published in 1977, is a republication of the work originally published in 1866 by George N. Barnard, New York. A new Preface by Beaumont Newhall has been specially prepared for this edition.

This republication has been made possible through the cooperation of The New-York Historical Society, who kindly loaned the publisher their original edition for reproduction purposes.

International Standard Book Number: 0-486-23445-2
Library of Congress Catalog Card Number: 76-45964

Manufactured in the United States of America
Dover Publications, Inc.
180 Varick Street
New York, N.Y. 10014

PREFACE TO THE DOVER EDITION

GEORGE N. BARNARD was a veteran photographer when he joined General William Tecumseh Sherman on his campaign through Georgia and the Carolinas during the Civil War. He was born in Connecticut on December 23, 1819. In 1843 he opened a daguerreotype gallery in Oswego, N. Y. In that city, on the night of July 5, 1853, he made his most famous daguerreotypes —two views of burning mills—that are perhaps the earliest news photographs taken in America. *(Fig. 2)* He was highly respected by the profession, was secretary of the New York State Daguerreian Association, and two of his genre daguerreotypes were reproduced in the *Photographic Art Journal*. In 1854 he moved to Syracuse, N. Y., and that same year won Honorable Mention in a national competition sponsored by the daguerreotype equipment manufacturers and dealers, E.

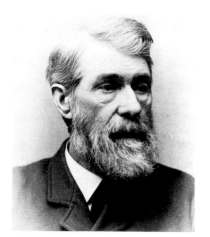

1 Portrait of George N. Barnard, taken in Plainsville, Ohio, between 1884 and 1886. Collection Onondaga Historical Association, Syracuse, N. Y.

and H. T. Anthony. When the daguerreotype process became obsolete late in the 1850s, Barnard, like all his contemporaries, turned to the newly invented collodion process.

It was slow, exacting and bothersome to work the new technique, which was called the "wet plate" process because the negatives were sensitized on the spot, by dipping glass plates coated with a mixture of collodion and a halide salt in a solution of silver nitrate, exposed while moist, and developed at once. If the collodion dried, it could not be processed. This necessitated a darkroom in which to work, and in the field this was a tent or a wagon.

There is evidence that Barnard worked in Cuba in 1860, documenting sugar and molasses production, but none of these photographs has been located. His earliest known collodion photographs are of the Civil War, taken in 1862: they show battlegrounds and landmarks of the first battle of Bull Run, after the recapture of the area from the Confederates. Presumably Barnard was then in the employ of Mathew B. Brady, for in September, 1862, the proprietor of a photographic gallery in Oswego named T. Gray boasted in an advertisement in a local newspaper that he had "secured the services, for a limited time, of that celebrated artist, George N. Barnard (formerly of this city, and late from Brady's Gallery, Washington)." Certain it is that Brady included photographs which he credited to Barnard in his series of cartes-de-visite, "Incidents of the War."

Brady, the most widely known daguerreotypist of New York and Washington, had a passion for recording history with the camera. He had already collected portraits of distinguished Americans, and when the Civil War broke out he determined to document the scenes of conflict and the personalities involved by photography. Failing eyesight, contemporary magazines noted, precluded his use of the camera himself, but he organized a group of cameramen, and "Brady's Photographic Corps" soon became well known at the front, complete with the horse-drawn darkrooms that the troops called "What-Is-It" wagons.

By 1863, Barnard had returned to the theater of war, now as official photographer of the Military Division of the Mississippi. Under the command of General Sherman, the army marched from Tennessee through Georgia to the sea, then north through the Carolinas. It was a decisive campaign; with the simultaneous operations of Grant's army to the north, it brought the Civil War to an end.

To the Northerners, Sherman's campaign, in the boldness of its plan, the brilliance of its execution, the drama of its swift advances, and the decisiveness of its victory, was a glorious triumph. Reminiscences by those who fought appeared in great number. On the wave of this public interest, Barnard privately published the portfolio of original photographs which is here reprinted for the first time.* The size of the

* In the present edition, the photographs are reproduced at 76% of original size. The captions to the plates have been corrected and slightly expanded. A map is reproduced from the original edition which includes most of the landmarks cited in the text and shown in the photographs. Three other maps in the original publication, requiring color-coding which was not feasible in the present edition, have been omitted.

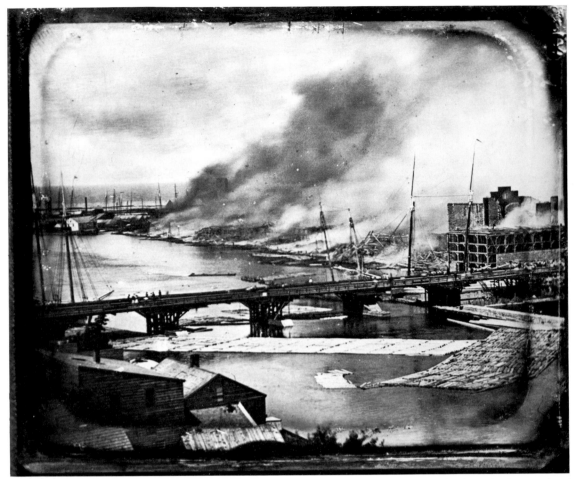

2 Burning Mills at Oswego, N. Y., 1853. Daguerreotype by George N. Barnard. Collection The International Museum of Photography, Rochester, N. Y.

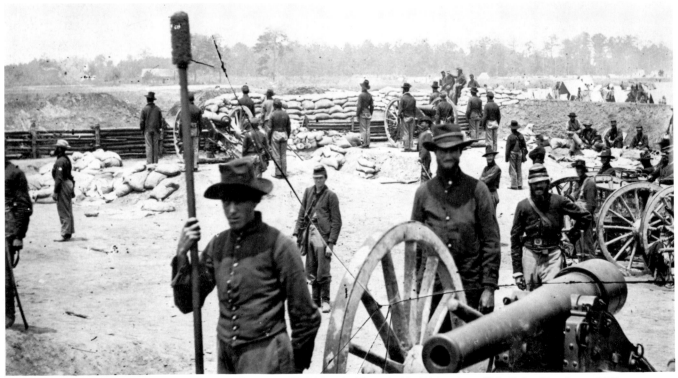

3 Capt. Rufus D. Pettit's Battery G, 1st N. Y. Light Artillery, in Ft. Richardson, Fair Oaks, Va., June, 1862. Photograph by George N. Barnard. Collection The Library of Congress, Washington, D. C.

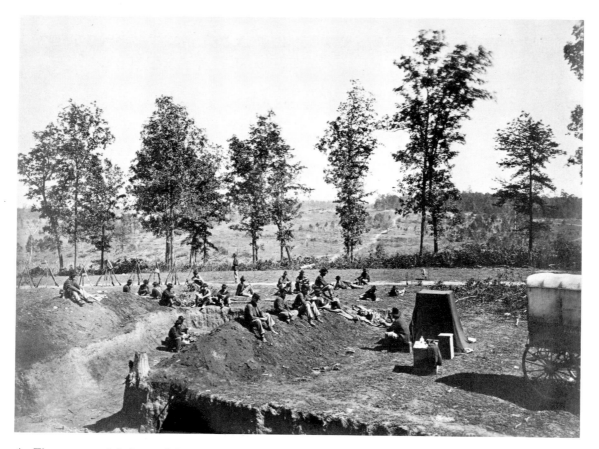

4 The wagon and darktent of George N. Barnard in fortifications before Atlanta, 1864. Photograph by George N. Barnard. Collection The Library of Congress, Washington, D. C.

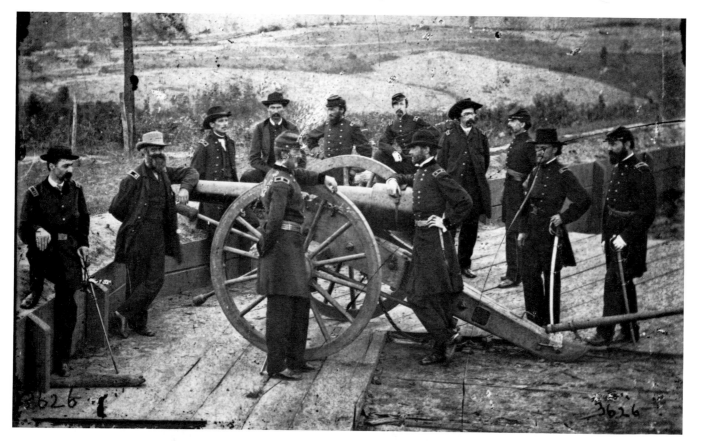

5 Gen. William T. Sherman (right foreground) and staff at Federal Fort No. 2, Atlanta, Ga., 1864. Photograph by George N. Barnard. Collection The Library of Congress, Washington, D. C.

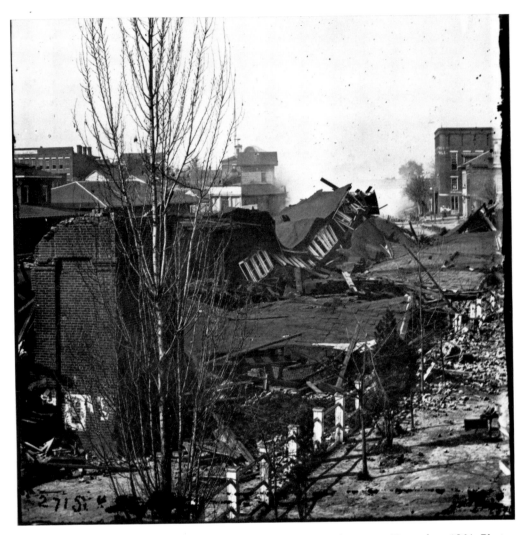

6 Ruins of Atlanta railroad station, demolished on Sherman's departure, November, 1864. Photograph by George N. Barnard. Collection of The Library of Congress, Washington, D. C.

original edition is not known, but to judge by the rarity of existing examples it was small. It is a landmark of the history of photography as well as of the Civil War.

Barnard wrote Sherman of his plan. The general replied from St. Louis on March 24, 1866: "I have your letter of March 17, and approve highly your purposal to publish a Series of Photographic Views illustrative of our Army operations about Chattanooga, Atlanta and generally of what we know as the Campaign against Savannah and through the Carolinas. I now have a great part of the Series and believe that in connection with the Maps, they will be very interesting and instructive to the General reader. I am truly your friend, W. T. Sherman, Brig Gen"

The book was reviewed in *Harper's Weekly,* December 8, 1866: "These photographs are views of important places, of noted battlefields, of military works; and, for the care and judgment in selecting the point of view, for the delicacy of execution, for scope of treatment, and for fidelity of impression, they surpass any other photographic views which have been produced in this country—whether relating to the war or otherwise. . . . We believe that only a very limited number of these volumes are issued; but although, from its expense, the book can not be popular, those who can afford to pay one hundred dollars for a work of fine art can not spend their money with more satisfactory results than would be realized in the possession of these views."

The first objective of Sherman was the capture of Atlanta, which was a vital railhead for the Confederates. The advance from Tennessee was slow, for the most part over bitterly contested mountainous terrain; the first thirty of Barnard's photographs are mostly of the heavily forested land where fighting was fierce. They show trees wracked by gunfire, hastily constructed fortifications, great wooden trestle bridges replacing those destroyed by the Confederates in their retreat. To us, the significance of most of these landscapes becomes evident only when the circumstances are known, and these are supplied in part by Barnard in a 32-page

booklet published separately as a prospectus and explanation of the portfolio.* Such photographs as the series of three of the battlefield of New Hope Church, Ga. *(Plates 25-27)*, with acres of broken, torn and twisted trees and hastily thrown up breastworks, need to be viewed while reading Barnard's words: "The Twentieth Corps was soon hotly engaged fighting in woods, and under brush, through which a storm of bullets and canister was rushing like a storm-wind. Tops of trees and heavy branches were falling in splinters among the advancing troops. . . . As night fell, a drenching rain-storm, which had threatened during the day, commenced. The troops were rapidly fortifying their position and continued their work until a rude breastwork was constructed."

We might take the Etawah Bridge *(Plates 23, 24, 33)* for granted, until we learn from Barnard that its 620-foot span was constructed by 600 men in six days, or that the five-story Whiteside Bridge *(Plates 4, 6)* was built entirely of timber cut in the area. "Scene of Gen. McPherson's Death" *(Plate 35)* is a peaceful forest scene, but for the caption and the bleached bones and skull of a horse—which we assume to be that of the fallen hero.

With the capture of Atlanta on September 1, 1864, the subjects of Barnard's photographs change from wild country to captured enemy strong points, exact in their detail of guns and emplacements. And destruction: of the ordnance train that the Confederate general Hood blew up in his retreat *(Plate 44)*, nothing remains but the wheels and axles, neatly lined up beside the trackless roadbed; all that stands of the railroad repair shop are five tall chimneys and a massive flywheel. Over the scene of desolation Barnard has added—as was the general custom of the time—a glorious cloudscape, printed from a second negative. Sherman turned Atlanta into an armed camp. All civilians were evacuated, banks were neatly blown up *(Plate 46)*, the railroad station destroyed *(Fig. 6)*. It was a prelude to the infamous March to the Sea, from November 15 to December 21, 1864, when Sherman led 60,000 troops, who were given tacit license to plunder, maraud and pillage. Strangely, not one photograph of that 50-mile-wide swath of destruction appears in the portfolio. Barnard wrote in his Introduction: "The rapid movement of Sherman's army during the active campaign rendered it impossible to obtain at the time a complete series of photographs which should illustrate the principal events and most interesting localities." And he went on to say, "Since the close of the war the collection has been completed." The last fifteen photographs of the album were taken in Savannah, Columbia, S. C., Fort Sumter and Charleston, S. C. Mostly they are of ruined buildings. There is no evidence of active warfare, no trace

* The entire text, repaginated, is reproduced following this essay.

of military occupation, no soldiers, no materiel. They are, for the most part, stark records of the aftermath.

After publishing, from an address on Broadway, New York, *Photographic Views of Sherman's Campaign,* Barnard returned to Syracuse. He moved to Chicago in 1869. The great fire of 1871 destroyed his gallery. He

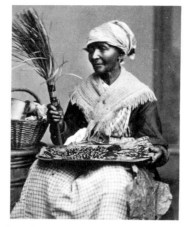

7 Street vendor, Charleston, S. C., about 1875. Photograph by George N. Barnard. Collection The International Museum of Photography, Rochester, N. Y.

recorded the ruined city as it was being rebuilt in a series of photographs reminiscent of his war scenes. We next hear of him in Charleston in 1875; there he specialized in taking and publishing stereographs: a memorable series documents types of black street vendors, taken in his studio *(Fig. 7)*. In 1883 he was briefly associated with George Eastman in Rochester, N. Y., promoting the gelatin dry plates that were replacing the already obsolete collodion process. He had a studio in Plainsville, Ohio, from 1884 to 1886. He died in Cedarville, N. Y., on February 4, 1902.

BEAUMONT NEWHALL

SOURCES AND ACKNOWLEDGMENTS

The most complete biography of Barnard is by Anthony M. Slosek, in his *Oswego County, New York, in the Civil War,* Oswego, N. Y., Oswego County Civil War Centennial Committee, 1964. Barnard's obituary appeared in *Anthony's Photographic Bulletin,* 1902, pp. 127-28. The letter from Sherman, and the portrait taken late in Barnard's life, are in the collections of the Onondaga Historical Association, Syracuse, N. Y.; I am indebted to Richard N. Wright, President of the Association, for bringing these to my attention and for permission to reproduce them; he has also provided much biographical information. And I thank The Library of Congress and The International Museum of Photography at George Eastman House, Rochester, N. Y., for permission to reproduce photographs in their collections.

B. N.

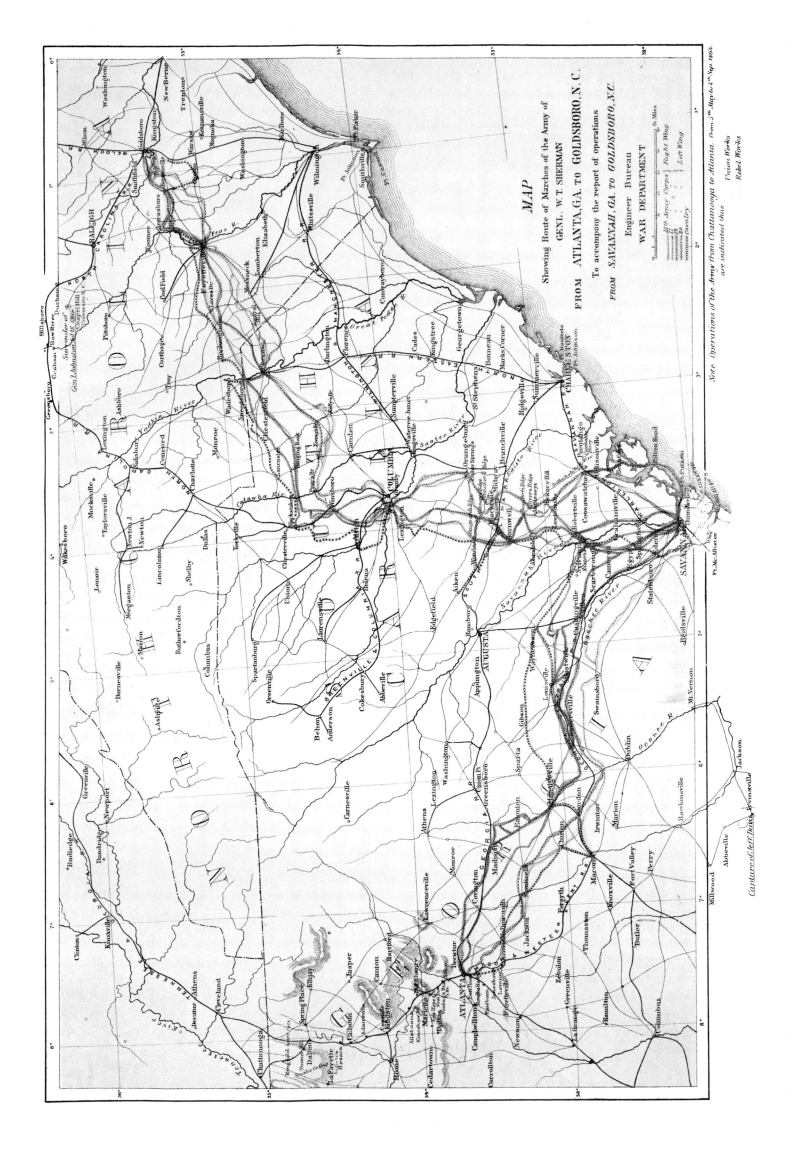

MAP
Showing Route of Marches of the Army of
GENL. W.T. SHERMAN
FROM ATLANTA, GA. TO GOLDSBORO, N.C.
To accompany the report of operations
FROM SAVANNAH, GA. TO GOLDSBORO, N.C.
Engineer Bureau
WAR DEPARTMENT

14th Army Corps { Right Wing
Left Wing
Cavalry

Note. Operations of the Army from Chattanooga to Atlanta, from 5th May to 4th Sep. 1864.
are indicated thus

Union Works
Rebel Works

Capture of Jeff. Davis

SHERMAN AND HIS GENERALS

THE movement on Atlanta from Chattanooga may be considered as the opening of General Sherman's great campaign.

During one of the early marches of the Atlanta campaign General Sherman remarked: " When we reach Atlanta the campaign will be but just begun. It is my plan; if I fail the onus is mine. The successful completion of my plans entitles me to any credit that may result. Grant is aware of my purpose, as I have submitted my plans to him and we act in concert."

When General Sherman concentrated his force in front of Resaca his army was divided for convenience of handling. McPherson's command—the Army of the Tennessee—was composed of the Fifteenth Corps, under General Logan ; Sixteenth, General Dodge ; and Seventeenth, General Frank P. Blair. The Army of the Cumberland, under General George H. Thomas, comprised the Fourth Corps, General Howard ; Fourteenth, General John M. Palmer ; and Twentieth Corps, under General Hooker. The Army of the Ohio consisted of the Twenty-third Corps, under General J. M. Schofield. The cavalry force was comparatively small and not concentrated to act as a unit. General McPherson's death, at the commencement of the bloody fight of July 22, 1864, left the Army of the Tennessee under the command of General Logan, who gained the respect and confidence of its soldiers by the splendid manner in which he retrieved the fortunes of that hard-fought battle. General Howard was placed in command of the Army of the Tennessee. General Stanley, the senior division commander of the Fourth Corps, succeeded to the command of the corps. General Hooker was soon after relieved, at his own request, of the command of the Twentieth Corps, to which command General A. S. Williams succeeded until the arrival of General Slocum. General John M. Palmer was relieved of the command of the Fourteenth Corps, General Jeff C. Davis succeeding him. After the fall of Atlanta the Sixteenth Corps was merged into the Fifteenth and Seventeenth. During the campaign to Savannah General Sherman's immediate command was the Army of Georgia, under General Slocum, composed of the Fourteenth Corps, General Jeff C. Davis, and the Twentieth Corps, General A. S. Williams ; and the Army of the Tennessee, under General Howard, embracing the Fifteenth Corps, General Osterhaus ; and Seventeenth, General Blair. The entire cavalry force, under Kilpatrick, did not exceed three thousand five hundred men. General Logan joined the army at

Savannah and took command of the Fifteenth Corps. General Mower, then a division commander of the Seventeenth Corps, was, during the campaign, ordered to command the Twentieth Corps. At the close of the war General Howard was detailed as Chief of the Freedmen's Bureau and Logan was placed in command of the Army of the Tennessee, General Hazen succeeding as commander of the Fifteenth Corps.

General Thomas fought the battles in the vicinity of Nashville with the Fourth and Twenty-third Corps and portions of such other commands as could be hastily brought together. Hood's army, beaten and disorganized, left Thomas free to dispatch General Schofield with the Twenty-third Corps to join Sherman at Goldsboro.

Of the corps commanders of Sherman's army Hooker, Logan, Blair, and Mower were the leaders most esteemed by the soldiers for dash and apparent disregard for personal safety, other commanders being regarded with respect for their soldierly qualities as commanders and men of personal bravery.

The erection of the capitol at Nashville was commenced some years previous to the outbreak of the late rebellion. The location selected was a commanding elevation in the center of the city, which places the base of the capitol somewhat higher than the roofs of the majority of the buildings near.

During the siege of the city by General Breckinridge in 1862. the capitol was strongly fortified by J. St. C. Morton, of the Engineer Corps, U. S. A., and converted into the citadel of the fortifications about the city. The stockades at the entrances have been removed, but a greater portion of the earthworks still remain. This edifice is the only State capitol that was fortified during the late war. From the cupola an extended and interesting view is obtained of the different battle-fields of the locality, the principal of which were the last battles, usually known as the " Thomas fights," the latter of which was one of the few battles of the war fought throughout on a plan previously matured.

It was not a difficult task to find in our army of volunteers men who could construct anything from a watch to a locomotive. Great bridges were rapidly rebuilt with no other tools than the ax and auger, convenient forests furnishing the timber.

The great bridge at Whiteside, as originally constructed, stood upon five piers of masonry, connected by arches of timber. This structure was destroyed by the rebels a short time previous to the

battle of Chickamauga. The present bridge was erected by the First Michigan Engineers and mechanics, assisted by the Railroad Construction Corps, during the fall and winter of 1863. The trestle is composed of five stories of round timber cut from the adjacent forests.

The importance of the bridge rendered it necessary to establish a permanent post near. Block-houses and rifle-pits were constructed, and a sufficient number of good troops detailed as garrison; the snug army homes of the bridge guard, form the picturesque foreground of the picture, giving a general view of the bridge.

Among the passes in the Raccoon Range there are none so picturesquely wild as the Running Water Pass, near Whiteside. It has been the theater of more than one of the early struggles between settlers and the Indians.

CHATTANOOGA.

On a peninsula formed beneath the shadow of Lookout Mountain by the sinuous course of the Tennessee river is located the town of Chattanooga, which was occupied by the Army of the Cumberland immediately after the fierce battle of Chickamauga in September, 1863. The position, naturally strong, was at once fortified by the construction of forts, connected by carefully laid-out lines of rifle-pits extending to the river bank above and below the town. For some time the difficulty of feeding the army was a subject of serious consideration. The only route open to the trains was over mountain road and through Tennessee mud—a distance of nearly forty miles. Mules starved to death by the hundred; batteries were left without a sufficient number of horses to move a single gun; the soldiers were reduced to such necessity for food that parched corn was a luxury. Canteens were unsoldered and made into graters to furnish meal of such corn as could be obtained.

The bridges thrown across the Tennessee were of the worst description. The pontoons composing them were built hastily of such material as could be obtained. The river was swollen, rapid, and filled with drift-wood, which continually carried away or sunk the pontoons.

The month of October, 1863, was not a season of plenty with the brave boys of the Army of the Cumberland. It must be well remembered by those suffering in the hospitals from wounds received in the battle of Chickamauga. General Rosecrans was relieved by General George H. Thomas, and General Grant arrived to take command of the army that was then being concentrated at this point. General Hooker brought from the Army of the Potomac the Eleventh and Twelfth Corps, camping in Lookout Valley on the evening of the 28th of October, with the advance of his command.

General W. F. Smith, then acting as Chief Engineer, presented at this time a plan for the supply of the army until the rebels could be driven off Lookout Mountain and the railroad communication repaired and opened. General Hazen, then commanding a brigade of the Fourth Corps, was intrusted with the execution of this plan. Pontoons manned by picked troops were floated down the Tennessee past Lookout Mountain just before dawn, and a lodgment effected at a point known as Brown's Ferry, distant from the enemy's batteries on the mountain some three miles. Pontoon bridges were thrown across at this point, and a new route obtained over which to transport the needed rations and forage.

The number of mules that were lost on this route will be appreciated by the account of some soldiers of the Army of the Tennessee who came over the route: "The mud was so deep that we could not travel by the road; but we were enabled to come along very nicely by stepping from mule to mule as they lay where they had pegged out along the road."

As soon as General Sherman arrived in the vicinity of Chattanooga with the Fifteenth Corps, preparations were made to attack the rebel positions on Lookout Mountain and Mission Ridge.

Orchard Knob was attacked, and carried on the afternoon of the 23d of November.

At daylight on the morning of the 24th General Hooker initiated the movement which resulted in the capture of Lookout Mountain. The story of this gallant fight may be told as follows:

General Geary, with his "White Star Division," effected, by a well executed movement, the ascent of the mountain-slope some distance to the right of the rebel position, and moved toward the "nose of Lookout." General Osterhaus, with a division of the Fifteenth Corps, and General Cruft, with his division of the Fourth Corps, attacked the rebel works along the base of the mountain. Seeing Geary's men in their rear and the determined attack in front, the rebels in these works surrendered. Cruft's division at once joined Geary and formed on his left, with the exception of General Whittaker's brigade, which was sent to the extreme right. General Osterhaus occupied the extreme left. In this order the line swept around the mountain, carrying their flags through the clouds of mist and smoke into the view of the anxious watchers in Chattanooga. The mountain, with the exception of its curious crown, was in the possession of the troops under General Hooker shortly before two o'clock in the afternoon. The crest of the mountain was abandoned by the rebels during that night.

The capture of Lookout uncovered and caused the rebels to abandon their entire line of intrenchments extending across the Chattanooga Valley to Mission Ridge. On the morning of the 25th General Hooker, with his command, descended the mountain and marched to the Rossville Gap in Mission Ridge. General Sherman had effected, by complete surprise, a lodgment on the northern point of Mission Ridge, crossing the Tennessee river between the Citio and Chickamauga creeks in pontoons and flats to secure a position until pontoon bridges could be thrown across.

The battle of Mission Ridge was commenced early in the day by Sherman with a gallant attack delivered against a strong position of the rebels near the railroad tunnel.

After driving the rebels out of Rossville Gap General Hooker ordered General Osterhaus to pass through the gap and move his division down the ridge. General Cruft, with his division, moved on the top of the ridge, and Geary down the western slope.

In order to support the troops attacked on the right and left, a considerable number of men were sent by Bragg from the center, which was broken by a splendid charge of the Fourth and Fourteenth Corps directly up the face of the ridge.

By this movement the ridge was carried, with the exception of its northern extremity, toward which Generals Sheridan and Baird at once marched their divisions, and continued the fighting far into the night. General Meigs, chief quartermaster of the army, was with the men of General Baird's division during their charge up the ridge and took an active part in the turning of captured guns upon their late possessors. He also directed the construction of temporary rifle-pits.

During the progress of the battle Generals Grant and Thomas occupied Orchard Knob as a position from which to observe and direct the movements of troops. It was in this fight that one of General Grant's staff was wounded, the first casualty that had occurred to a member of the General's staff during the war.

Hooker's pursuit of Bragg was terminated at Ringgold, Georgia, by a fierce engagement never dignified by the name of battle although such it really was, as many who are familiar with the gallant fight made by General Osterhaus' division of the Fifteenth Corps will willingly testify.

Generals Sherman and Granger marched from Chattanooga with their commands, the Fifteenth and Fourth Corps, to the relief of General Burnside at Knoxville.

The battle of Chattanooga caused the retirement of Bragg to a strong position near Dalton, behind the Rocky-face Ridge. In this locality his army remained in camp during the remaining months of the winter, General Joseph E. Johnston relieving Bragg of his command.

Ringgold was occupied by General Baird's division of the Fourteenth Corps, and held as the advance position of the army until the opening of the Spring campaign.

Near the western entrance of the Rossville Gap is the house which was for a long time the house of John Ross, a chief of the Cherokee nation. The location is so fine, with reference to pure water and air, that it has been several times selected as a hospital site.

The general hospital of Rosecrans' army was located here after the battle of Chickamauga, but removed when the line was contracted to the limits of Chattanooga, when the house was at once occupied as a general hospital for the sick and wounded of Polk's corps of Bragg's army.

During the Atlanta campaign the wounded from General Sherman's army were comfortably cared for here until the hospital on Lookout Mountain was completed.

Every effort was now made to accumulate stores at Chattanooga. Locomotives were brought from different railroads in the North,

and cars loaded with rations, ammunition, and forage came into Chattanooga by the hundred.

A fine bridge was constructed across the Tennessee river from plans furnished by General Meigs, who also superintended in part its construction. The bridge is rather peculiar in its construction, the arches are formed of green timber cut from the forests near. The bend requisite is secured by sawing cuts into and with the grain of the timber.

Tul-lu-la lake, a picturesque basin among the rocks of Lookout Mountain, still retains its Indian name, the translation of which is, the lake among the mountains. The waters of this Indian mirror are as pure and clear as possible. If we may believe the Indian legends, it possesses peculiar properties for healing other ills than those of the body. It is certainly the favorite resort for "swain and lass" of the country near.

Near the lake are huge boulders deeply covered with moss of a great variety of color and quality, surpassing anything of the kind that may be found in our more northern wilds.

The Buzzard's Roost Pass in the Rocky-face Ridge received its name from the fact that its vicinity was for a long time the resort of persons whose character, if they had any, was doubtful in the extreme. The Pine-top whisky made near, was said to be the worst and cheapest that was ever made in the State of Georgia. Whisky and the bowie-knife must have done their work, for the Buzzard's Roost is as uninhabited a locality as one can find in that very poor country, Northwestern Georgia.

The campaign to Atlanta opened with a demonstration in front of the Buzzard's Roost, a sort of an entertainment gotten up for the amusement of the rebels until McPherson should secure the Snake-creek Gap, the initiation of one of the best flanking movements of the war.

The maneuver gained for our army a position which would have resulted in the defeat of Johnson had General Sherman's orders been strictly obeyed.

To quote General Sherman will be the most simple way of explaining the position :

"Resaca was important and almost unguarded."

"If the movement could have been perfected as successfully as it was commenced Johnson's army would have been in the North Carolina mountains without a wheel. Moments that were as precious as days were wasted, and prolonged battling inaugurated."

Kilpatrick opened the engagement with a brush with Wheeler's cavalry, which he succeeded in driving back.

In this cavalry dash General Kilpatrick received a wound which disabled him for some weeks. The opening of the battle of Resaca was a series of brisk engagements, resulting from the getting into position of different corps.

On the 14th of May the divisions of General Newton (formerly Sheridan's), of the Fourth Corps, and General Judah, of the Twenty-third, made a determined attack on the rebel right. Although they did not succeed in carrying the entire position, they were enabled to secure such a line as to make their position

annoying and to attract a considerable rebel force to the vicinity.

During the 14th of May, 1864, the lines were formed, General McPherson slowly pressing forward with the Army of the Tennessee on the right until within easy shelling range of Resaca and the bridges over the Oostanaula. In the town scarcely a single house remained unmarked by shot or shell. The bridges, being more difficult to hit, were not seriously injured by our shell-fire. Generals Palmer and Schofield were slowly but surely gaining ground in the center.

On the afternoon of the the same day General Hooker was ordered to the left with the Twentieth Corps, and effected a junction with the left of General Howard's Corps (the Fourth) just in time to meet and repel an attack then being made by the rebels with a view of enveloping the left flank. On the morning of the 15th General Hooker moved forward until in front of a strong position fortified, and held by Claiburne's division. The sight of "red dirt" was to the troops indicative of hard fighting. Dispositions were hastily made. General Butterfield's division was ordered forward to carry the works by assault. The undergrowth about the rebel lines so concealed them as to render a careful reconnoissance impossible—the troops moved rapidly up the slope and succeeded in entering the works, when, to their surprise, they received a galling fire from strong rifle-pits still in their front. This drove them to the coveted exterior slope of the captured work, which now proved to be a strong salient or redoubt thrown out in advance of the main line. General Ward, of Kentucky, led his brigade into the work, and vainly endeavored to get his men forward for the purpose of attacking the main line. It is said that the General mounted the parapet of the redoubt just captured and made a few complimentary remarks to his command, closing with the announcement that any soldier desiring to die for his country would now have the opportunity. The extreme bravery of the action so astounded the rebels that they refrained from firing on the gallant General, who, already severely wounded, was forced to rejoin his command in front of the captured line. Four light twelves that were in the work were held by our men though they were not able to carry them off.

The following letter, captured soon after the battle of Resaca, gives a very capital version of the assault :

"RESACA, May 15, 1864.

"MY DEAR WIFE—John Tomson is going home to Cassville, wounded, and I thought I would drop you a line by him. The Yankees charged my battery this afternoon and captured two sections of it, and many of the men in attendance were wounded. It was as daring an exploit as when my brother's battery was charged upon at Antietam, Maryland, by a New York regiment. They threw themselves into the fort (in his words) as unconscious of danger as so many ducks in a pond. Tell Joe and Will to stow away everything of value, fearing that we should have to fall back from here. If we do, the Yankees will get everything within their reach.

"Hooker's command we had to fight here, or else the battery would never have been taken. I hear we are gaining on the Yankees in Virginia, and we would here, and whip them, were it not for Hooker's command—they all wear a star. Don't answer this. If we hold our ground here I will see you ere long. I want you to send Sis. and James to grandpa's for a week, and you go to Uncle John's. Take all the things that you can. I must close, as the bearer is about leaving.

"Your husband until death,

W. W. CASPAR.

"P. S. Our position here was very good, but we have to fall back. Keep up good courage. I hope what I have said will not prove discouraging to you.

"W. W. C ."

The captain left four of his guns in such a position that it was impossible for the rebels to secure them. As soon as night fell spades were procured and the work in front of the guns dug away until the pieces could be passed through. This performance was accomplished within thirty yards of a strong rebel line.

The most comprehensive view of the location of Resaca and its surroundings is to be obtained from the fortified knoll near the town, held by the rebels until the last moment. This work was finally occupied by the skirmishers of the Fifteenth Corps. The bridges over the Oostanaula were partially destroyed by the rebels after their retreat, on the morning of the 16th of May.

General Morgan L. Smith were so closely pursuing them that sufficient of the road ridge was saved to enable the pioneers to repair it to be used for crossing the Fourteenth Corps. The Alatoona Pass was now generally regarded by the army as the next strategic point.

The Etawah river was to be crossed before reaching the pass, which was understood to be strongly fortified. The defenses of the Etawah bridge were known to be well laid out and carefully constructed. Plans of the railroad bridge over the Etawah had been in the hands of the Construction Corps for a sufficient length of time to enable them to furnish a duplicate.

Trains from Chattanooga with the bridge on board were soon on the road, and every preparation made to repair the destroyed portions of the railroad as rapidly as possible. The movement was now to place the army in such a position as to draw Johnson into battle upon open ground. This offer was declined by Johnson, who continued a successful retreat to the strong positions behind the Etawah.

Slight engagements occurred near Adairsville between a portion of the Fourth Corps and the rebel rear-guard, and in the vicinity of Cassville, when Hooker, with the Twentieth Corps, nearly succeeded in securing a battle.

Meanwhile General McPherson, with the Army of the Tennessee, was pushing steadily forward to cross Burnt Hickory Hills toward Dallas, General Thomas following by a shorter route in

such a position as would enable him to support General Schofield, who was executing a feint upon Johnston's position at Allatoona.

The movement was discovered by Johnston, who moved his army out of the defenses of Etawah and Allatoona Pass toward New Hope Church, evidently determined to defeat Sherman in the forests of the Burnt Hickory Hills. If he could have accomplished this, Sherman would have been forced to fight at a disadvantage, and away from the railroad, with a short supply of rations in his wagons. The crossing of Pumpkin Vine creek was effected at three different points before Johnson could reach it to dispute the passage.

The first crossing was made by a company of the Fifteenth Illinois cavalry, then acting as escort to General Hooker. Colonel James D. Fessenden and Captain Duncan, of General Hooker's staff, discovering the rebel advance, led the escort on so determined a charge as to occupy the rebels' attention until General Williams' division of infantry could be moved across.

The Twentieth Corps was soon hotly engaged fighting in woods, and under brush, through which a storm of bullets and canister was rushing like a storm-wind. Tops of trees and heavy branches were falling in splinters among the advancing troops. The Fourth and Fourteenth Corps were hurried forward and extended on the left of the Twentieth, fighting as they formed. As night fell, a drenching rain-storm, which had threatened during the day, commenced. The troops were rapidly fortifying their position and continued their work until a rude breastwork was constructed. The officers were without tents or food. Fires were out of the question, the rain putting them out before they were fairly started. General Sherman and staff attempted to sleep in a sitting posture wrapt in their coats and saddle blankets. The wounded and dead were lying in all directions. One poor fellow badly hit made use of the sleeping form of a brave general as a pillow.

The battle thus begun on the afternoon of May 25 resulted in a continuued skirmish-fire, which was kept up for several days. Intrusive bullets were inconveniently plentiful. Camp-kettles filled with steaming coffee were suddenly emptied into the ashes of the fire. The quiet of the mess-table was invaded by singing Minies that broke the few remaining pieces of crockery belonging to the mess and sent scalding coffee into the wide legs of cavalry boots. Camp-stools that had seen service during long campaigns were splintered by bullet, and fragments of shell.

On the 28th of May a desperate attack was made near Dallas on General Logan's command, the Fifteenth Corps. The rebels met with a bloody repulse, which seemed to determine them to abandon the offensive plan of operation; and on the 4th of June they withdrew from their position and fell back to their first line in front of Kenesaw Mountain.

The railroad bridge across the Etawah was destroyed by the rebels in their retreat and rebuilt by the Railroad Construction Corps, ordered West and organized by General Meigs. The work of rebuilding this bridge—six hundred and twenty feet long—was accomplished by Colonel Wright, with six hundred men of the Construction Corps, in six days.

Ackworth now became the temporary base of supply. The wagon-trains were filled with rations, ammunition, and forage for the movement against Kenesaw Mountain.

The rebel line near Kenesaw Mountain was carefully constructed and entirely completed before the army of General Sherman made its appearance. The prospect of carrying these works by assault was so doubtful that flanking operations were the consequent movements.

The rebels were kept in their works by the troops in front, who were steadily pressed forward day by day. The rebels had spared no pains to make their works as strong as field fortifications could be constructed. Abattis, and head logs were here encountered for the first time during the campaign.

The Pine Mountain line was abandoned by the rebels only to retire to a stronger and more compact one, of which Kenesaw Mountain may be regarded as the center.

The rebels were not forced from this line without a number of engagements, mostly fought by corps or divisions. Though not dignified by the name of battle, these engagements were far from being insignificant skirmishes.

This series of engagements was opened by General Harrow's division of the Fifteenth Corps on the 15th day of June by an attack upon a strong position on the left of Kenesaw. The engagement was short and successful. Two regiments of rebel infantry were captured, and our line contracted and strengthened.

The Fourth and Fourteenth Corps were gaining positions day by day. On the 28th of June the Twentieth Corps, which had been moved some distance to the right, succeeded in gaining a position of such importance as to induce Johnston to attack it in force. General Hascal's division of Schofield's command—the Twenty-third Corps—was forming on Hooker's right when the attack commenced. The rebels were hurled back in such disorder that it was impossible to bring them forward again. This was the last offensive movement made by Johnston, who seemed determined to husband the men of his command by acting entirely upon the defensive.

By the contraction of the line, secured by close advance to the rebel works, the Fifteenth Corps was now occupying the ground lately held by the Fourth and Fourteenth in front of Little Kenesaw. To the right of this is a narrow gorge, in which vast masses of rock are tumbled in confusion. The natural strength of the place seemed to assure the rebels that no effort would be made to assault their line at this point. Aware of this fact, General Sherman ordered an attack to be made, hoping to penetrate the line at a point which would command the rebel line to the right for a sufficient distance to enable the Fourth and Fourteenth Corps to move on the rebel works in their front and secure the center of the rebel position.

General Morgan L. Smith's division of the Fifteenth Corps made the attack; but so much time was consumed in traversing the difficult ground over which they were forced to advance before

reaching the point of attack, that the rebels were enabled to so strongly reinforce the place as to make its capture impossible. The attack was continued for a considerable time before the order for withdrawal was received. The failure to get through at this point was expensive, as the loss of killed and wounded was very considerable for the small number of troops engaged.

To this attack the rebels responded by a continuous shelling from the batteries on Big and Little Kenesaw. The soldiers built traverses of earth and logs to protect themselves from the fire, and so strengthened the line that a great portion of it is still in existence. Preparations were at once made to attack a point farther on the right, and orders issued to the commanders of the Fourth and Fourteenth Corps to attack simultaneously on the following morning. The troops engaged in this advance were forced to move for a long distance over open ground, where they suffered heavily from a musketry fire kept up by the rebels from behind a strong line of breastworks which almost completely protected them from our fire. The attack was unsuccessful, though made in the most gallant manner by brave troops splendidly commanded. It was here that General Harker was killed, and General Daniel McCook mortally wounded. General John G. Mitchell was wounded, but not so seriously as to disable him.

The failure of these attacks to break through the rebel line determined General Sherman to resort to a heavy flanking movement to the right, which was completely successful, Johnston being forced to abandon the Kenesaw line and retire behind the Chattahoochee river. The army advanced at once to the north bank of the Chattahoochee, Marietta being made the temporary depot for supply.

It may be interesting to know the manner in which an army moving thus rapidly was supplied with the necessary commissary, quartermaster, and ordnance stores. Trains were constantly on the railroad *en route* from Chattanooga to the front. The Construction Corps, with their trains, followed the advance of the army so closely that they were frequently under fire while engaged in the repair of destroyed portions of the road. The Field Telegraph Corps was of great service, extending their lines through the country with the greatest rapidity. Constant communication with the headquarters of army commanders was secured, and from the headquarters of General Sherman with Washington.

The faultless working of the Telegraph Corps was but just being appreciated when it was found that sections of the insulated wires were disappearing in an unaccountable manner. Soon it was discovered that the soldiers were cutting the cable into lengths of a foot, when, by the extraction of the conducting wire from its gutta-percha covering, they obtained a flexible stem for their pipes. The trouble was only remedied by the issue of stringent orders for the punishment of any future depredations.

The crossing of the Chattahoochee was not effected without a considerable display of strategic maneuvers. General McPherson, with the Army of the Tennessee, secured a crossing nearly twenty miles above the point at which the river is spanned by the railroad bridge, and moved directly on Decatur, where he was met by General Schofield with the Twenty-third Corps.

The Army of the Cumberland crossed in the vicinity of the destroyed railroad bridge, which Colonel Wright, with the Construction Corps, was already rebuilding. The crossing was effected without difficulty, and the troops pressed forward to and across the Peach Tree creek, when an attack was made by heavy masses of rebel infantry. The brunt of the battle fell upon the Twentieth Corps, and gave to the troops in it that lately composed the Eleventh Corps an opportunity to regain the honors lost by them at Chancellorsville. Brigades composed exclusively of men from the Eleventh Corps went into line, firing by file upon the rapidly advancing lines of gray. The right of the Fourth and left of the Fourteenth Corps, became engaged at the same time. During the brief continuation of this fight the roll of musketry was incessant until the rebels were beaten back in confusion, leaving their dead and wounded in our hands.

The "Blue Star" division of General Ward sent seven flags to General Hooker as their portion of colors captured.

This battle was the result of, first, a succession of desperate attacks upon our army by General Hood, who had now been placed in command of the rebel forces. The removal of General Johnston and the substitution of General Hood were regarded by our troops as a very satisfactory arrangement. The constant care exercised by Johnston to avoid any engagement that should possibly take his command at a disadvantage had forced General Sherman to be the attacking party, or to resort to flank movements. Hood evinced a willingness to fight that augured badly for the safety of his army.

The retreat conducted by General Johnston from Resaca to the vicinity of Atlanta was one of the most perfect in history. Not a straggler was left behind to give information. A broken-down horse or mule was a curiosity. It is safe to say, that the feeling of Sherman's army for General Joseph E. Johnston as a soldier was one of admiration.

The 20th and 21st of July were occupied in placing the army in position. By this it must not be understood the simple forming of connections between one army and another, but the taking up of position and selection of line that should enable them to assume the offensive or defensive, as developments should require.

The position of the different corps in the line of battle, from left to right, was as follows: Sixteenth, Seventeenth, Fifteenth, Twenty-third, Fourth, Twentieth, and Fourteenth.

Before daylight on the 22d of July the rebel works in our immediate front were discovered to be deserted. A part of the line was occupied before daylight, and the remainder very soon after. That Atlanta was not deserted one could readily discover, as an anterior and apparently stronger line nearer the city was visible from the lately abandoned works. If this were not sufficient, the constant rush of shell through the air and the thud and explosion as they reached our line gave the confirmation required.

This day was to witness the bloodiest scene of the great Sherman

campaign. The story of the battle is simple. On the extreme left the Sixteenth Corps was engaged in the destruction of the railroad from Decatur to Atlanta, with orders to move as soon as their work was complete, down a country road, and form on the left of the Seventeenth Corps, refusing the line to a point nearer the railroad.

The destruction of the railroad was soon complete, and the column moving down the road to join the Seventeenth Corps, when they were attacked in the flank by the enemy in heavy force

The sudden attack forced the column back from the road to a position in the field to the right.

Battery F, Second United States, was lost here, the rebels capturing some of the cannoneers while they were endeavoring to unlimber the pieces. General McPherson, unattended except by a single orderly, rode rapidly down the line toward the point of attack. The General, supposing that the Sixteenth Corps had connected with the Seventeenth, followed the continuation of the line of the latter corps, and by so doing went through the space left between the left of the Seventeenth and right of the Sixteenth Corps directly into the rebel line. He was killed instantly by a musket bullet fired by one of a small squad of rebel skirmishers. These did not obtain possession of his body, which was soon after conveyed to the rear by members of his staff.

By this time the battle was raging along the line of the entire Army of the Tennessee.

General Logan, as senior corps commander, assumed command and at once turned his attention to the recapture of the guns lost during the earlier part of the engagement. The extreme bravery with which assaults upon different divisions were met and repulsed was the reason of the total failure of the rebels to accomplish their attempts to break through our line.

Hospital and wagon trains were frequently under fire. Teamsters left their mules and went into the fight. Numbers of of the rebels who bravely charged the lines reached them only as prisoners.

Near the right of the Army of the Tennessee stood a fine residence, "The Howard House." Here General Sherman had located his headquarters. By an attack on the right, mainly directed toward the position occupied by Captain DeGress's battery of twenty-pounder Parrots, the rebels succeeded in capturing the battery. The gallant style in which these guns were served during this attack is still spoken of by General Sherman as one of the brave deeds that came under his observation during the war.

The desperate and unexpected attack made by the rebels on the battery caused the supports to give way. Captain DeGress, discovering that his guns were gone, determined to make their capture by the rebels as expensive as possible. Ordering the guns pointed left oblique, he gave the charging columns double canister at the rate of four rounds per minute. To save his men he ordered the two pieces nearest the rebels to be spiked, continuing, however, a rapid fire with the remaining section. The charging columns had nearly reached his battery when DeGress ordered his men to get back to the main line, and remained himself, with a sergeant

(Peter Wyman), using one gun as rapidly as possible.

Still the enemy came on, and when, within twenty steps, an officer called on him to surrender, DeGress, who stood with the lanyard of either gun in his hand, shouted, "Certainly, come!" at the same time discharged his two guns, and called to Wyman, who stood with pincers and spikes to spike under cover of the smoke and get away. DeGress saw the spike driven into the vent of the the last gun, then left with a storm of bullets whistling about him. The sergeant was killed, but Captain DeGress escaped unhurt, to meet General Logan coming to his assistance at the head of Colonel Martin's brigade. "General," said DeGress, "I have lost my battery." "No," remarked Logan, "Wood's guns have been turned on your horses, and we will have this brigade charging clear of the Johnnies before they can move your guns" In less than a quarter of an hour DeGress, who had gone in with the charging column, was busy drawing the spike from one of his guns, which was soon sending canister into the retreating rebel infantry officers acting as cannoneers.

Darkness closed the battle of Atlanta. The loss on our side was three thousand five hundred men and ten guns; the enemy left in front of the Army of the Tennessee two thousand one hundred and forty-two dead, more than three thousand prisoners, and eighteen stand of colors.

Our losses were heavy, and largely composed of the best troops in the army. General McPherson was in himself a host, and a loss that caused a general gloom to pervade the entire command. In no one of our armies was there such general good feeling and *esprit du corps* as in the Army of the Tennessee. Jealousy was almost unknown; officers of one corps were ever ready to welcome with applause a gallant deed performed by other corps. McPherson had been with them from "Shiloh," and was regarded with the respect that had been first Grant's, then Sherman's.

It seemed impossible that McPherson was gone. His loss was to these troops as a star torn from the flag. General McPherson died as he had lived, a true-hearted man and a gallant soldier; the instant death he had met did not rob his face of the smile that seemed its natural expression. Tears trickled down the cheeks of many a bronzed-faced soldier as the word passed down the line that McPherson was gone. For an instant, the roar of musketry ceased, then broke forth in volleys that sent back the rebel line broken and disordered. Private George J. Reynolds was near the General when he fell.

HEADQUARTERS SEVENTEENTH ARMY CORPS,
DEPARTMENT OF THE TENNESSEE,
BEFORE ATLANTA, GA., July 2, 1865.

GENERAL ORDER No. 8.

During the bloody battle of the 22d instant, in which this corp was engaged, Private George J. Reynolds, D Company, Fifteenth Iowa Infantry Volunteers, was, while in the performance of his duty on the skirmish line, severely wounded in the arm. In attempting to evade capture he came to the spot where the late beloved and gallant commander of the army, Major-General McPherson, was lying mortally wounded. Forgetting all consider-

ation of self Private Reynolds clung to his old commander, and amid the roar of battle and storm of bullets administered to the wants of his gallant chief, quenching his dying thirst, and affording him such comfort as lay in his power. After General McPherson had breathed his last private Reynolds was chiefly instrumental in recovering his body and assisting in putting it in an ambulance under a heavy fire from the enemy, while his wounds were still uncared for.

The noble and devoted conduct of this brave soldier cannot be too highly praised, and is commended to the consideration of the officers and men of this command.

In consideration of the gallantry and noble unselfish devotion the " Gold Medal of Honor " will be conferred upon private George J. Reynolds, Company D, Fifteenth Iowa Infantry Volunteers, in front of his command. This order will be read at the head of every regiment, battery, and detachment of this corps.

By command of
Major-General FRANK B. BLAIR.
(Signed) Lieutenant-Colonel J. Alexander,
Assistant Adjutant-General."

How good and brave a soldier was lost to the army when General McPherson fell will be appreciated by the following paragraph from General Grant's recommendation of him for promotion in the regular army :

"He has been with me in every battle since the commencement of the rebellion, except Belmont—at Forts Henry and Donelson, Shiloh, and the siege of Corinth. As staff officer and engineer, his services were conspicuous and highly meritorious. At the second battle of Corinth his skill as an officer was displayed in successfully carrying reinforcements to the besieged garrison when the enemy was between him and the point to be reached.

" During the advance through Central Mississippi, General McPherson commanded one wing of the army with all the ability possible to show ; he having the lead in the advance and the rear in retiring. In the campaign and siege of Vicksburg General McPherson and his command took unfading laurels. He is one of the ablest engineers and skillful generals. I would respectfully but urgently recommend his promotion to the position of brigadier-general in the regular army."

General Logan was placed temporarily in command of the Army of the Tennessee, General Howard being ordered to fill the vacancy caused by McPherson's death. This appointment caused General Hooker to ask to be relieved from his command. " If," said General Hooker, " Logan had been retained as commander of the Army of the Tennessee, I should have been satisfied and *glad*, for Logan is a good soldier. If a commander was to be chosen from another command, I should have had some preference from rank as well as service." General Hooker did not feel that he could respect himself if he continued to serve in an army where his services were not recognized. He asked to be ordered East.

It is difficult to appreciate the warm feeling of respect that was felt by the Twentieth Corps for General Hooker, his parting from the command of which was extremely affecting. No one regretted the necessity more than General Hooker. The battle of Peach Tree Creek was the last fight in which the Twentieth Corps was commanded by " fighting Joe Hooker," who had made them a second to none in the army. General A. S. Williams, the senior division commander of the corps, took command until the arrival of General Slocum, just previous to the fall of Atlanta. In a conference with the different commanders General Sherman remarked, "Gentlemen, I will move this army to the southwest of Atlanta, and it must fall." His first movement of troops to effect this was the ordering of the Army of the Tennessee to the extreme right of the line, their late position being held by a line of cavalry vedettes. The movement to the right seemed to meet a similar movement on the part of the enemy, who, on the 28th instant of July, attacked the Fifteenth Corps, then the extreme right of our line. The troops were but just going into position when the rebels made their advance.

The fight, which lasted several hours, resulted in one of the most bloody repulses sustained by the rebels during the war. Their killed and wounded lay within twenty yards of the rude breastworks thrown up during the early moments of the attack.

The fire of General Logan's men was so rapid as to heat their muskets to a degree that rendered them almost unserviceable. After the close of the engagement half melted bullets were drawn from muskets that had been used by men who had been killed or wounded. In conversation with some of the soldiers who were cleaning their guns directly after the battle, the information was received "that the barrels of the muskets got so hot that they made the wood-work smoke." The water in the canteens of the men was exhausted early during the battle, and caused the resort to an unusual method of cooling muskets. Six hundred and forty-two of the rebel dead were buried in front of General Logan's command, while the loss in wounded was extraordinarily heavy. Few prisoners were captured, owing principally to the nature of the ground, which was covered with heavy underbrush.

The " Atlanta Appeal " remarked shortly before the battle of the 28th, "that General Hood would succeed in annihilating his army in just three weeks if the style of fighting lately inaugurated was persevered in." But General Hood had discovered that attacking General Sherman's army was not a very satisfactory style of warfare. If he had succeeded at any time in breaking the line fresh troops were within easy supporting distance and would have overwhelmed his attacking column before they could have intrenched themselves in the position gained.

From the 29th of July until the 1st of September the army was steadily advancing until the line was sufficiently straightened to allow the detachment of the Fourth and Fourteenth Corps for a movement to the southwest of Atlanta. The capture of Jonesboro by these two corps and Kilpatrick's cavalry was one of the bravest and most successful efforts of the war. The fact that the fall of Jonesboro was to result in the abandonment of Atlanta seemed patent to the troops of both armies, and the struggle was prolonged and sanguinary. The works were carried. Gen-

eral Jeff C. Davis, commanding the Fourteenth Corps, turned in over one thousand prisoners and ten guns.

General Hood blew up his magazines, destroyed his stores, and abandoned Atlanta; which was directly occupied by General Slocum with the Twentieth Corps. The pursuit of the rebels was continued to "Lovejoy's Station," when the army was brought back to Atlanta, where they went into camp quietly, the first time for a number of weeks.

General Sherman remarked at the conclusion of his dispatch announcing the capture of Atlanta :

" We have, as the result of this quick, and I think well executed movement, twenty-seven guns, over three thousand prisoners, and have buried over four hundred rebel dead and left as many wounded. They could not be removed.

" The rebels have lost, beside the important city of Atlanta and stores, at least five hundred dead, two thousand five hundred wounded, and three thousand prisoners, whereas our aggregate loss will not foot one thousand five hundred.

" If that is not success I don't know what is."

The quiet of camp was of short duration. Forrest took advantage of this opportunity to raid through northern Alabama. Hood, by a rapid movement, reached the railroad between Atlanta and Chattanooga. General Sherman, in his dispatch, says :

" I reached the Kenesaw Mountain October 6th, just in time to witness at a distance the attack on Allatoona. I had anticipated this attack and had ordered from Rome, General Corse, with reinforcements. The attack was met and repulsed, the enemy losing some two hundred dead and more than one thousand wounded and prisoners. Our loss was about seven hundred in the aggregate. The enemy captured the small garrisons at ' Big Shanty ' and 'Ackworth,' and burned about seven miles of our railroad ; but we have at Allatoona abundance of provisions. Hood, observing our approach, has moved rapidly back to Dallas, and Van Wert and I are watching him in case he tries to reach Kingston or Rome. Atlanta is perfectly secure to us, and the army is better off than in camp."

In a field order issued by General Sherman, he says :

" The thanks of the army are due and are hereby accorded to General Corse, Colonel Tourlelotte, officers and men, for their determined and gallant defense of Allatoona, and it is made as a sample to illustrate the importance of preparing in time and meeting the danger when present, boldly, manfully, and well."

General Sherman, leaving Thomas north of the Tennsssee with sufficient force to confront Hood, moved back to Atlanta, from which place he set out on the 14th of November for Savannah.

General O. M. Poe, to whom was intrusted the duty of completing the destruction inaugurated by Hood, executed his orders to the entire satisfaction of General Sherman. The tools for the destruction of the railroad iron were invented by General Poe. By the use of these simple tools the iron was rendered entirely unserviceable without calling on the men for the severe labor usual upon the destruction of roads.

Shortly before dawn on the 22d of December Brigadier-General H. A. Barnum, of General Geary's division of the Twentieth Corps, discovered that the strong defenses in front of Savannah were unoccupied. The rebels had abandoned the works in General Barnum's front but a short time when the discovery was made. At sunrise the town was occupied by General Geary's division, whose splendid state of discipline will long be remembered by the citizens of Savannah. Prior to ordering the different commands to the portions of the city to be occupied by them, General Geary addressed the troops, asking that the reputation of the " White Star Division " should be kept as far above the stains that marauding and pillaging would cast upon it, as it had been when in front of the enemy, by the tried bravery of officers and men. The army was obliged to remain in and near Savannah until it could be clothed and equipped to start on the raid through the Carolinas. Soldiers that have performed much successful campaigning through an enemy's country soon weary of the quiet of garrison life.

The army had not been in Savannah a month before General Sherman was beset whenever he appeared among the camps with queries from his veterans as to the probable length of time that would elapse before a start was made for the Carolina campaign.

General Sherman left the line of the Savannah river early in February, 1865, and occupied Columbia, S. C., on the morning of the 17th. The sights of this day will never be forgotten by those who witnessed the devastation and suffering caused by the burning of the city.

The yet unfurnished edifice which was to have been the Capitol of the State of South Carolina, was one of the few buildings of any pretension that escaped the flames. The old Capitol was one of the first buildings burnt. The destruction done at Columbia was immense and sincerely regretted by a great portion of the army. An incident that occurred on the afternoon of the 17th will be remembered with pleasure, showing as it does the respect with which the memory of the soldiers who fell in the Mexican war is regarded. Near the new Capitol was erected a bronzed palmetto tree as a monument to the soldiers of South Carolina who fell during the war with Mexico. In the sides of the pedestal which form the base of the monument are placed in bronzed letters the names of the fallen heroes ; some ruthless campaigners were engaged in knocking off such of these letters as would designate their companies, when a number of soldiers interfered and posted a guard to prevent further depredations on a monument to the memory of men who died fighting their country's battles.

Charleston was occupied on the morning of the 18th of February by a small force under the command of Colonel Bennett of the Fifty-second Pennsylvania, and the old flag restored to its place over the battered remains of Fort Sumter. The rebels had committed several outrages previous to the abandonment of the city ; fires had been set in many different places and pillaging seemed to have been resorted to by as many soldiers as could absent themselves from their commands.

The Wilmington depot had been blown up and several lives lost. This accident occurred in the following manner : The rebels had left behind in the depot a large quantity of powder in kegs and cartridges. A number of boys thought it fine sport to throw the cartridges among the burning bales of cotton in the immediate vicinity. The powder dropped along the way to the fires soon communicated to the powder in the depot, and a terrific explosion followed which left the depot in ruin and flames. Over a hundred and fifty are thought to have been burned to death, while about a hundred more were wounded by the explosion.

The end of the great campaign occurred on the 14th of April, when Johnston made the first proposal looking toward negotiation. General Sherman agreed to meet General Johnston on the 17th, but in the meantime went on with his preparations for an action. At noon on the day appointed the two Generals met. This was the first time that Sherman had ever seen Johnston. " Our interview," he said, "was frank and soldier-like, and he gave me to understand that further war on the part of the troops (Confeder-ate) was folly. Their cause was lost, and every life sacrificed after Lee's army surrendered was the highest possible crime. He admitted that the terms conceded to General Lee were magnanimous and all he could ask ; but he did want some general concessions that would enable him to allay the natural fears of his followers and enable him to maintain his control over them until they could be got back to the neighborhood of their homes, merely saving the State of North Carolina the devastation inevitably to result from turning his men loose and unprovided on the spot to pursue their own way across the State. He also wanted to embrace in the same general proposition the fate of all Confederate armies that still remained in existence. I never made any concessions as to his own army, or assumed to deal finally and authoritatively in regard to any other ; but it does seem to me that there was presented a clause for peace that might be deemed valuable to the Government of the United States and was at least worthy of the few days that would be consumed in reference. To push an enemy whose commander so frankly and honestly confessed his inability to cope with me was cowardly and unworthy the brave men I led."

NOTE ON THE PHOTOGRAPHS

THE rapid movement of Sherman's army during the active campaign rendered it impossible to obtain at the time a complete series of photographs which should illustrate the principal events and most interesting localities. Since the close of the war the collection has been completed. It contains scenes of historical interest in Tennessee, Georgia, and the Carolinas ; photographic glimpses of important strategic positions ; field-fortifications, with their rude but effective obstructions ; and the great bridges, built by the army in an almost incredibly short space of time.

G. N. B.

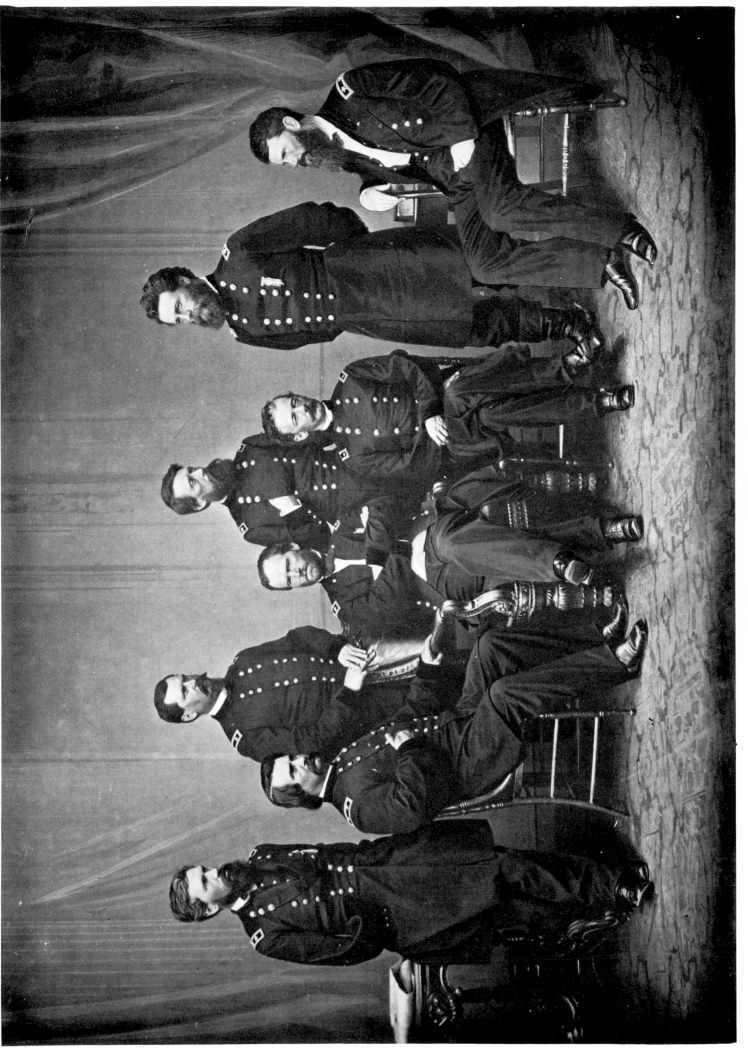

1 Sherman and His Generals

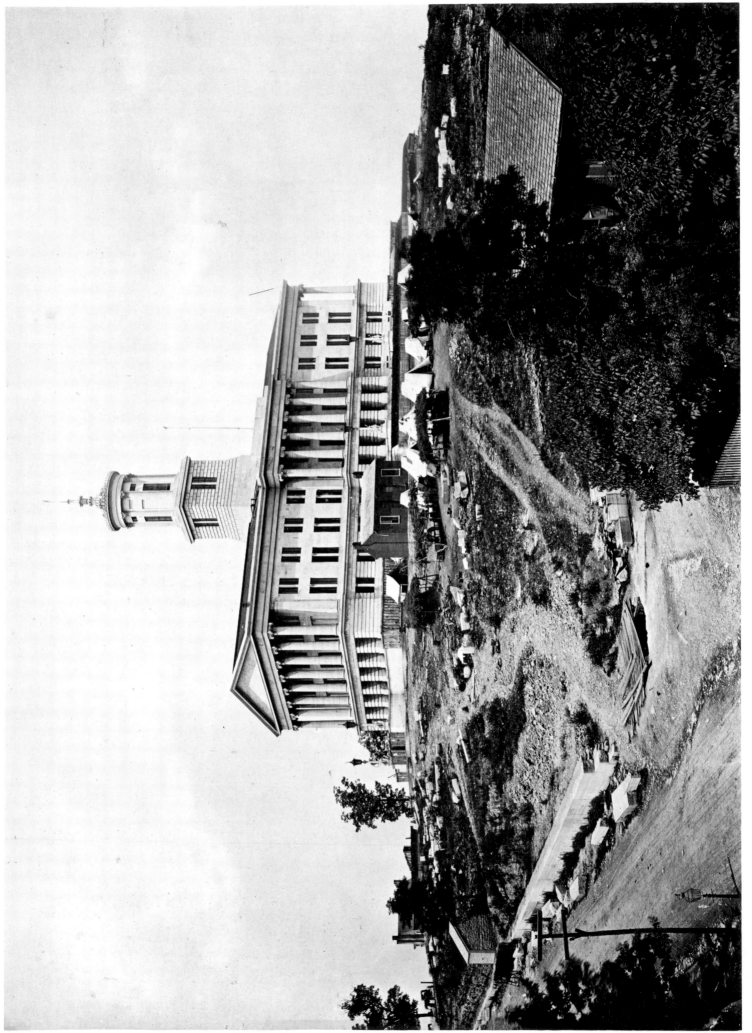

2　The Capitol, Nashville

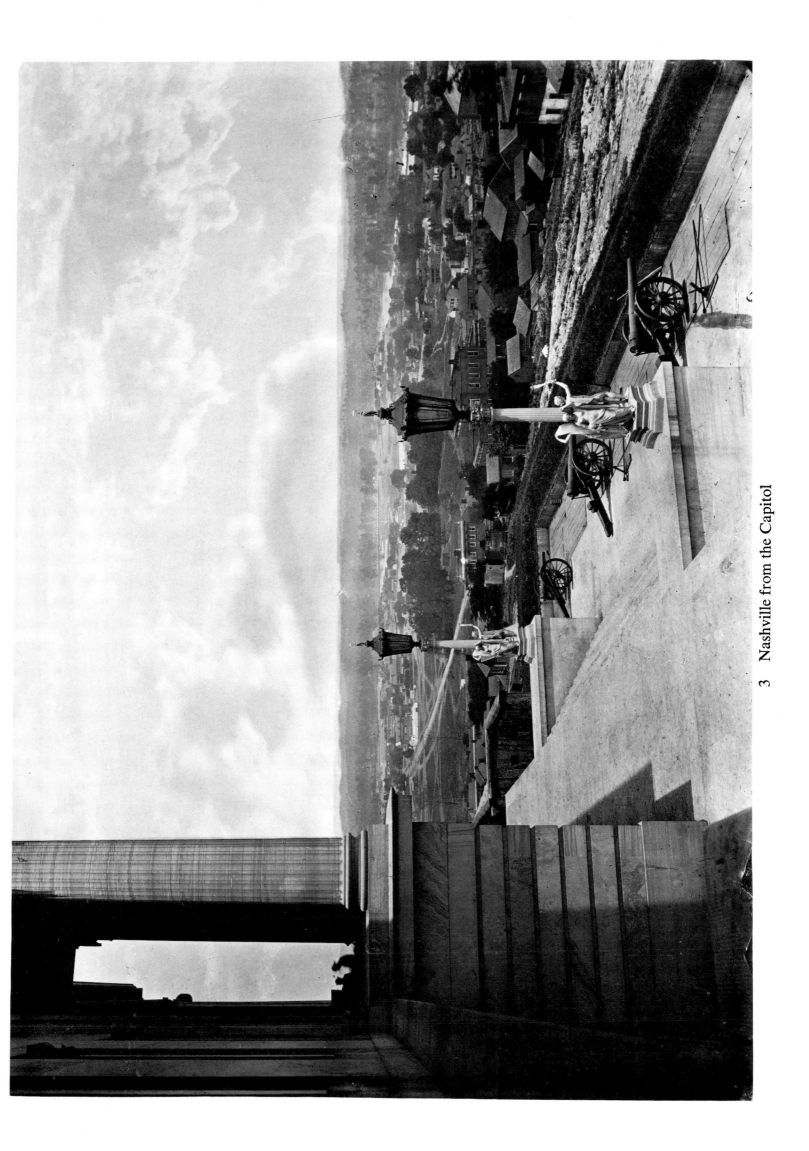

3 Nashville from the Capitol

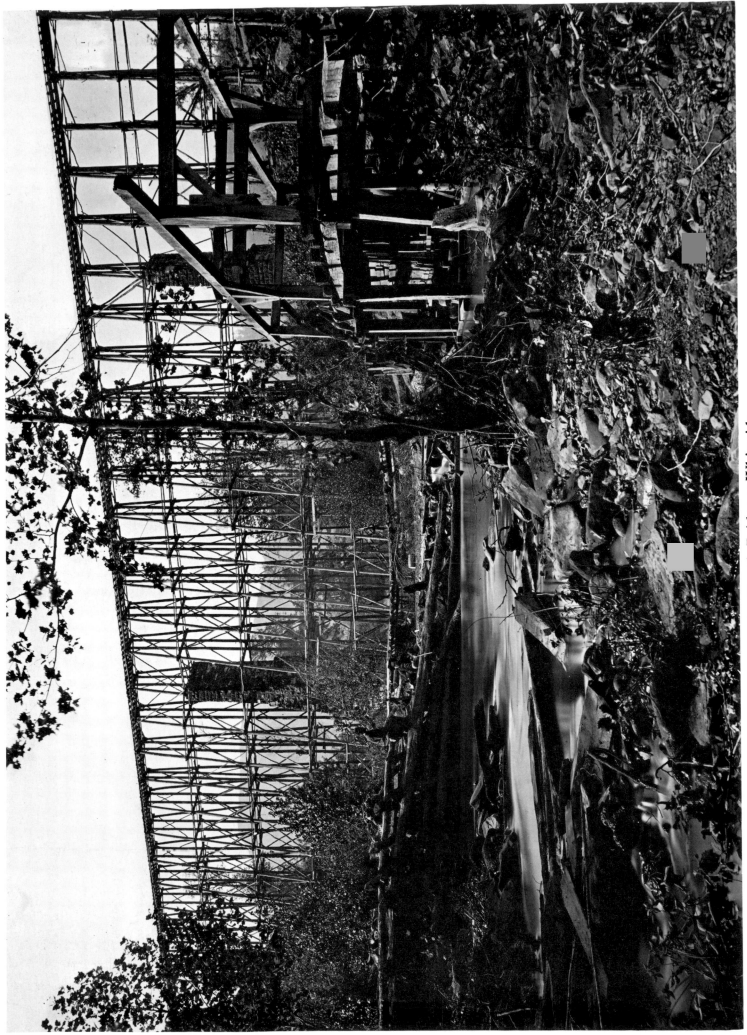

4 Trestle Bridge at Whiteside

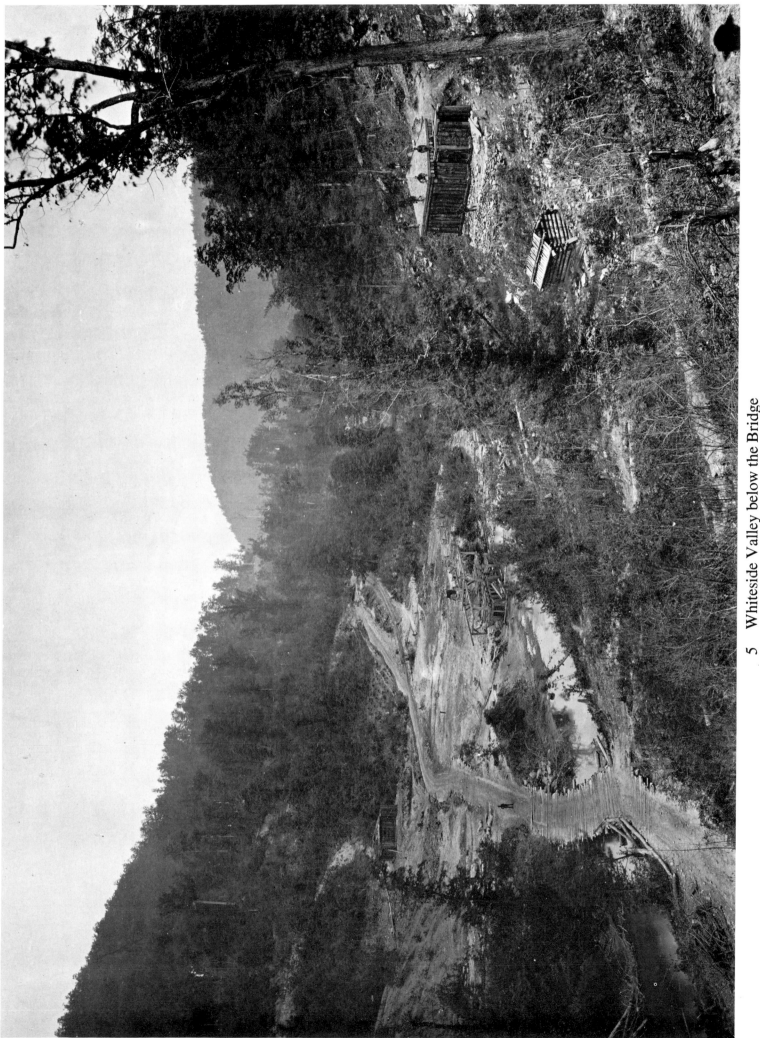

5 Whiteside Valley below the Bridge

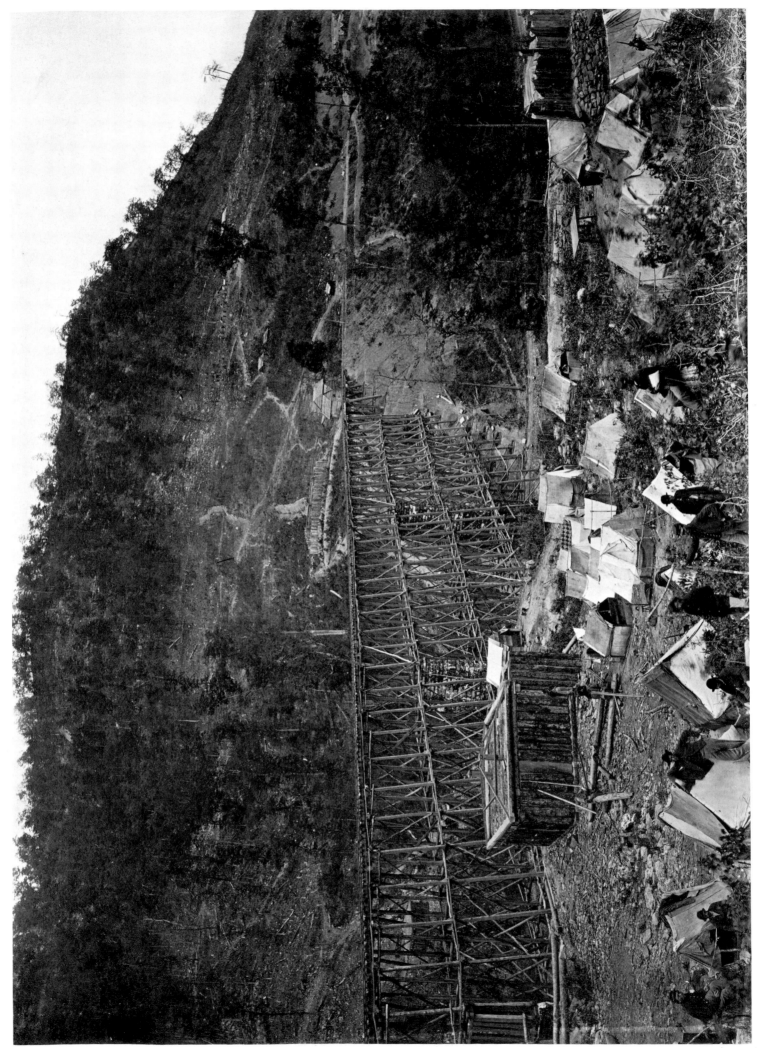

6 Pass in the Raccoon Range (Whiteside No. 1)

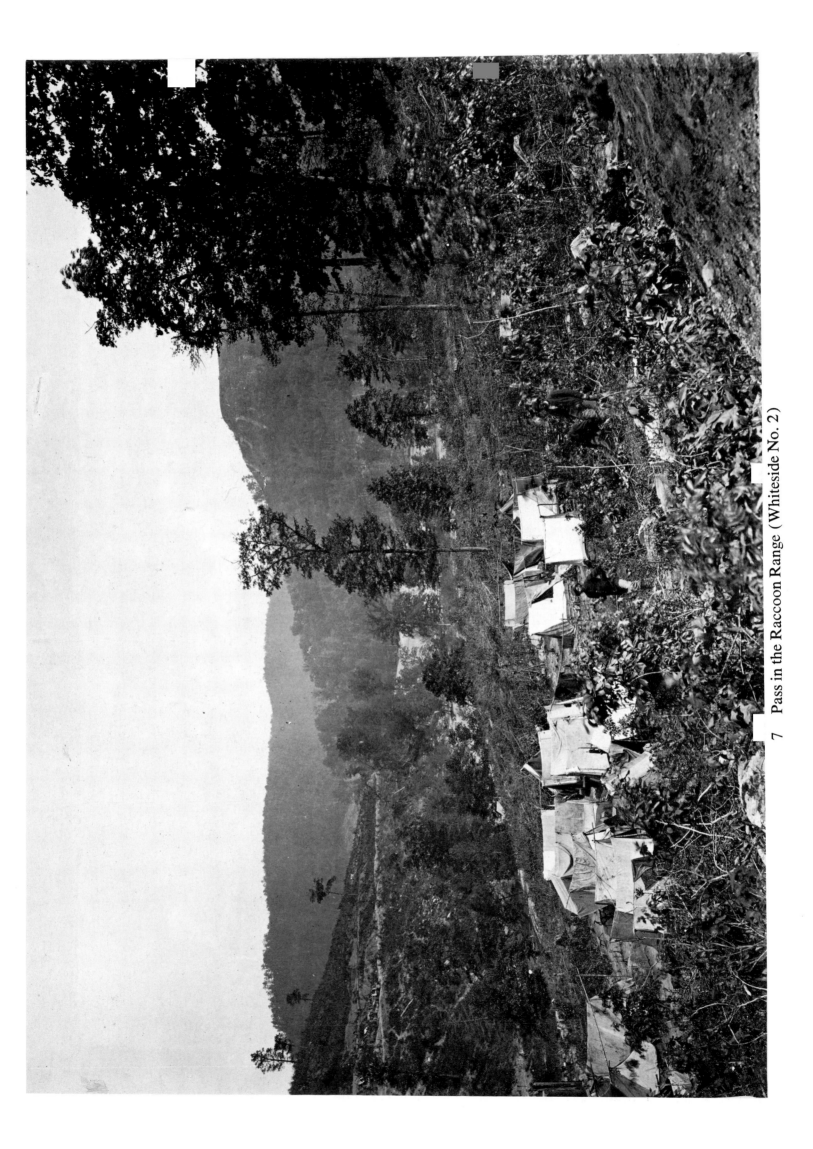

7 Pass in the Raccoon Range (Whiteside No. 2)

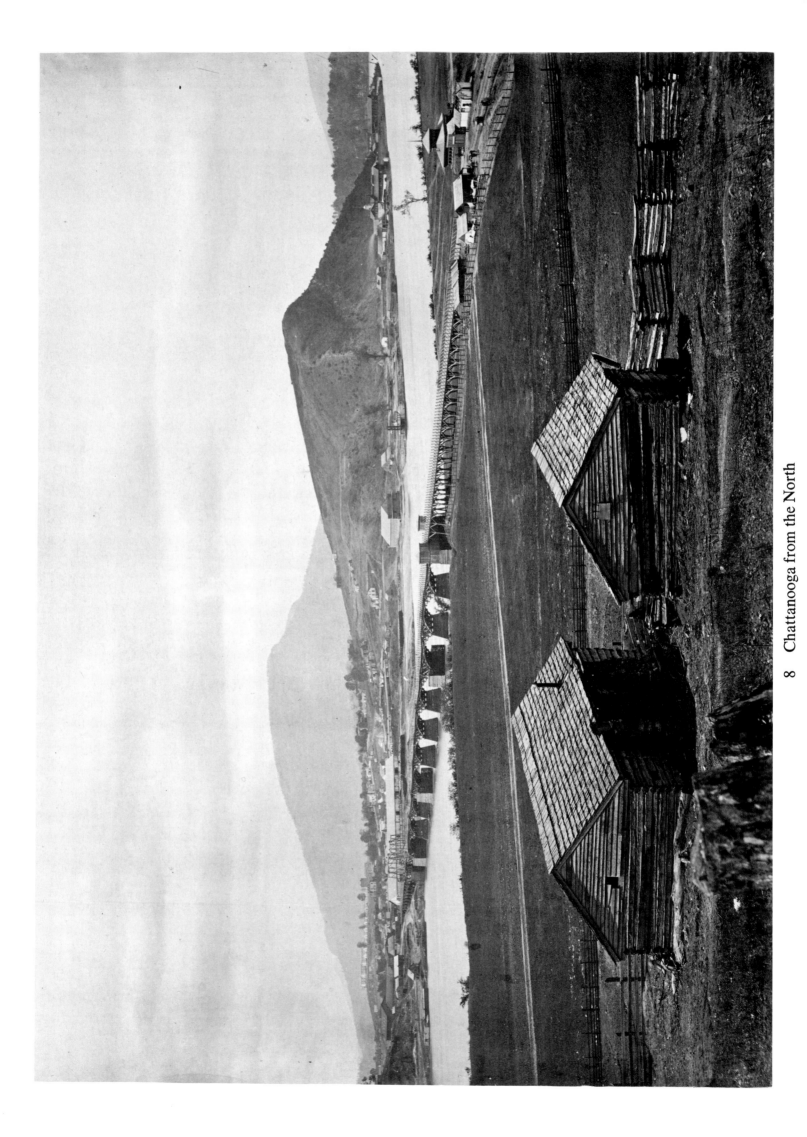

8 Chattanooga from the North

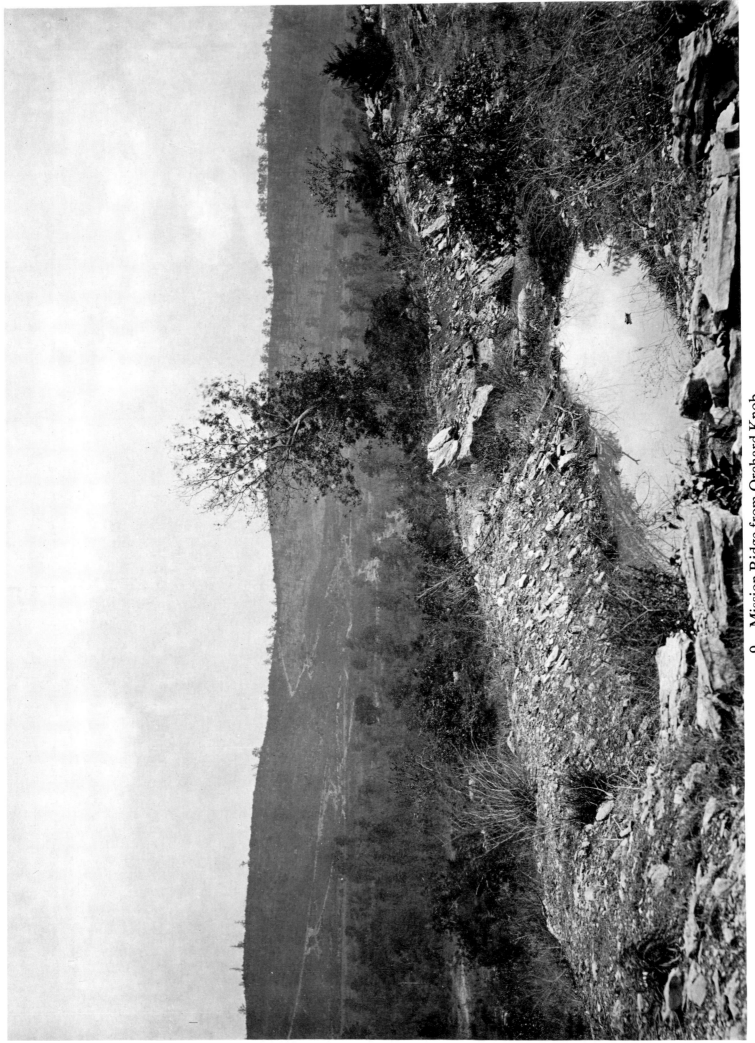

9 Mission Ridge from Orchard Knob

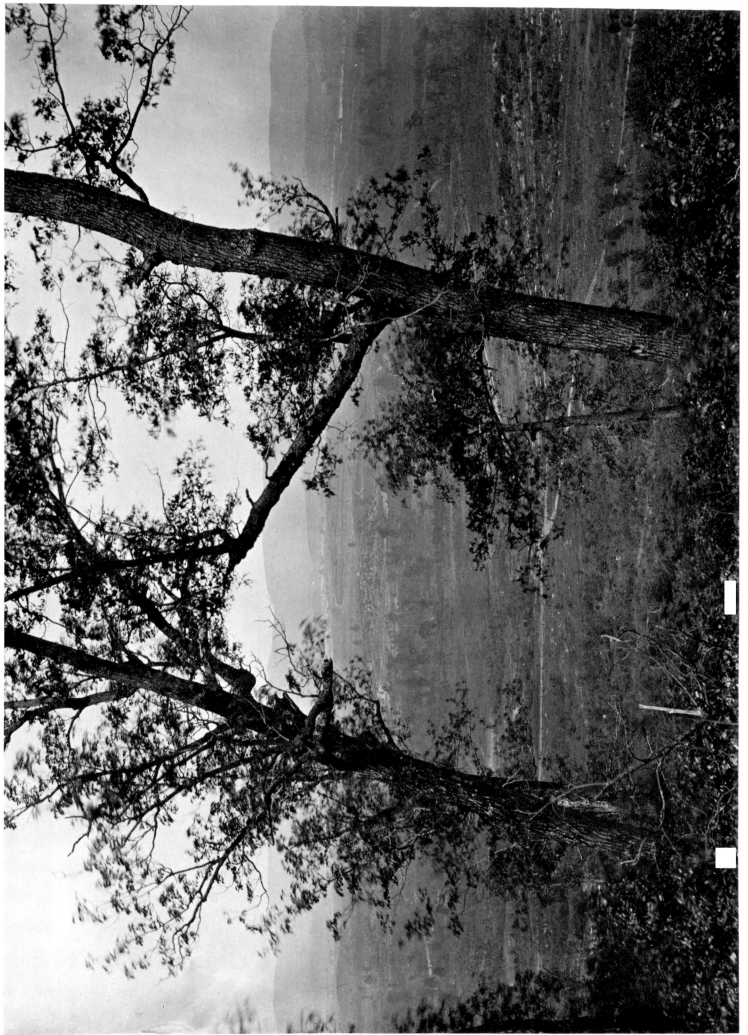

10 Orchard Knob from Mission Ridge

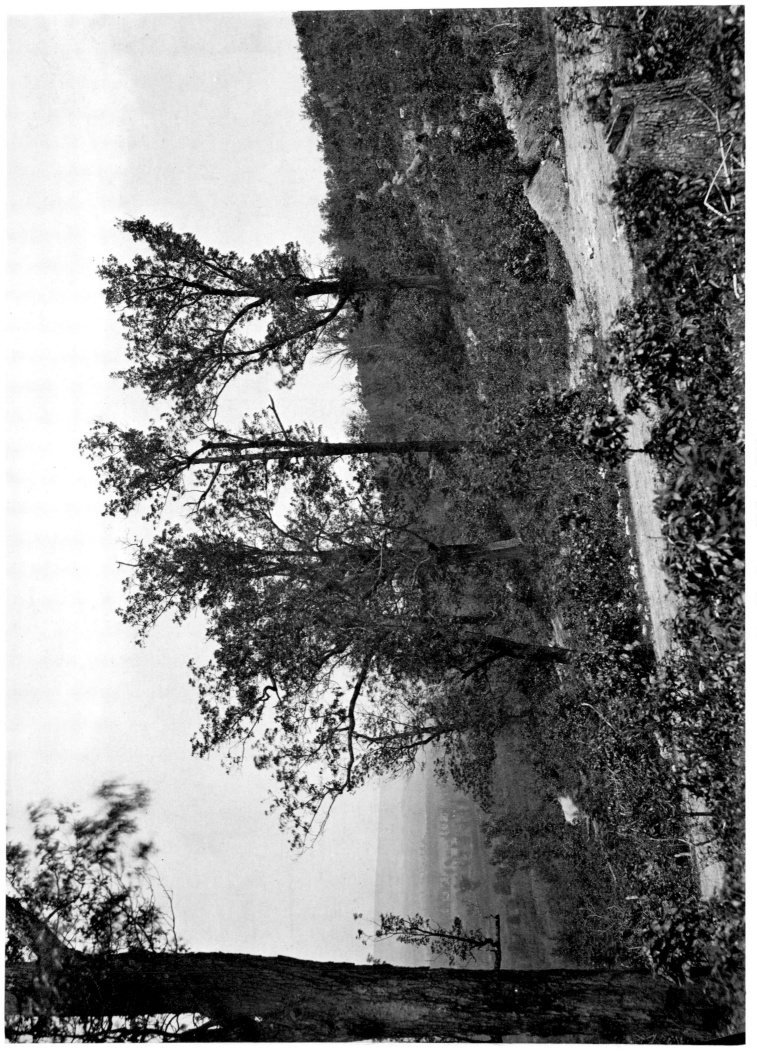

11 The Crest of Mission Ridge

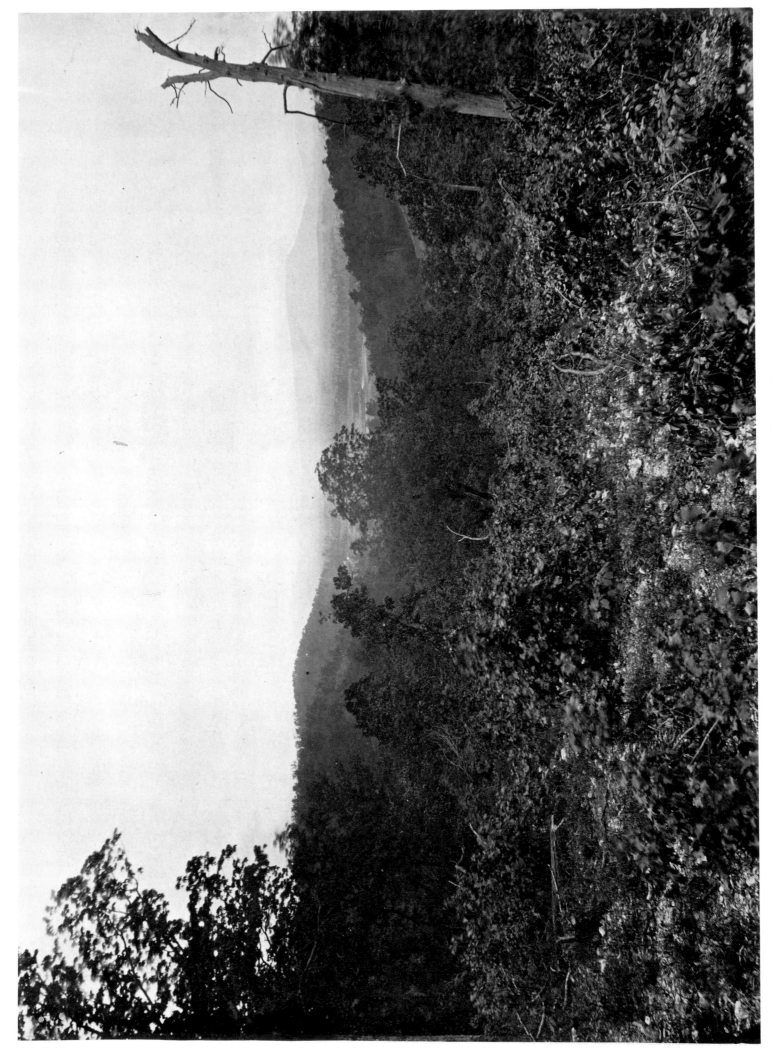

12 Mission Ridge, Scene of Sherman's Attack

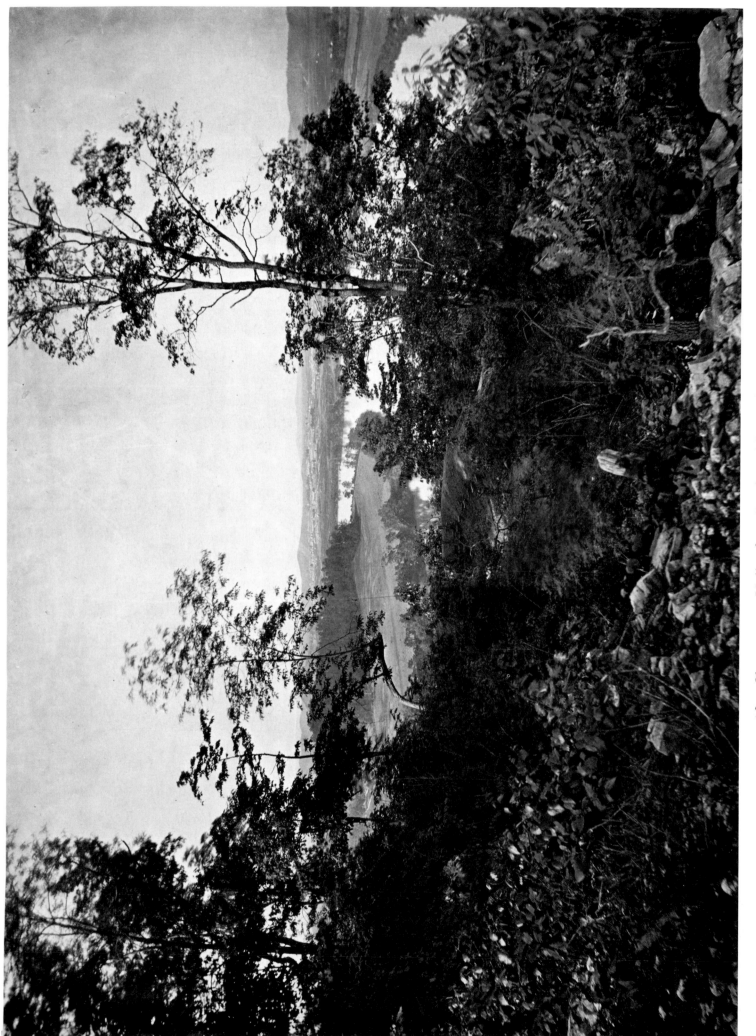

13 Chattanooga Valley from Lookout Mountain, No. 1

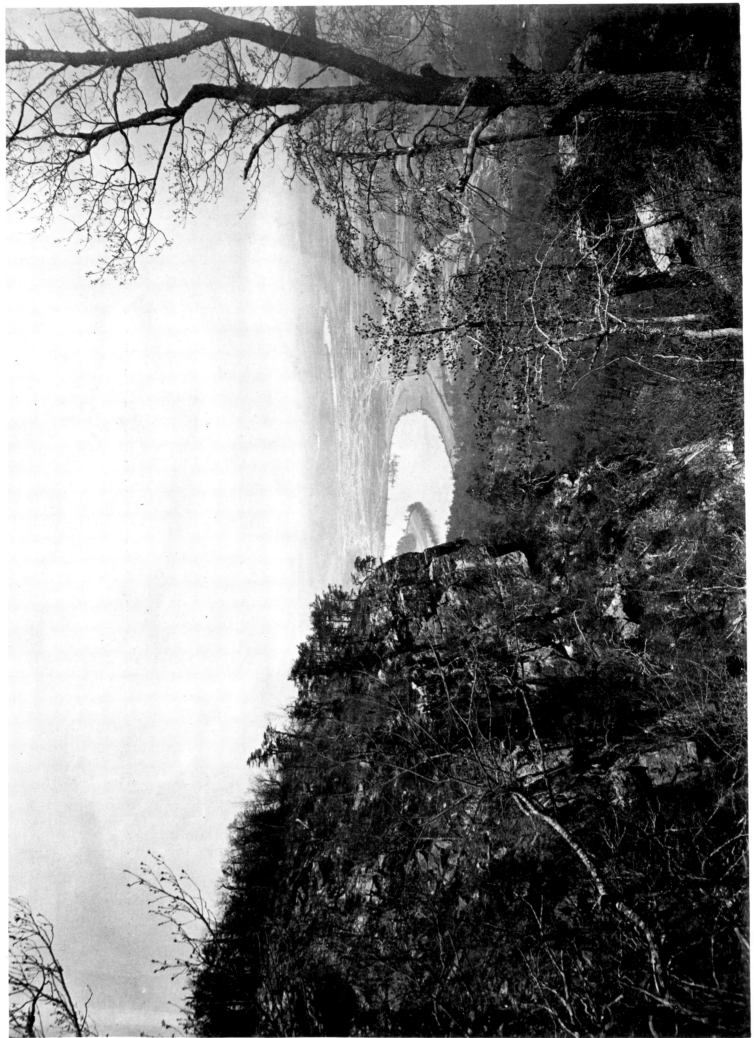

14 Chattanooga Valley from Lookout Mountain, No. 2

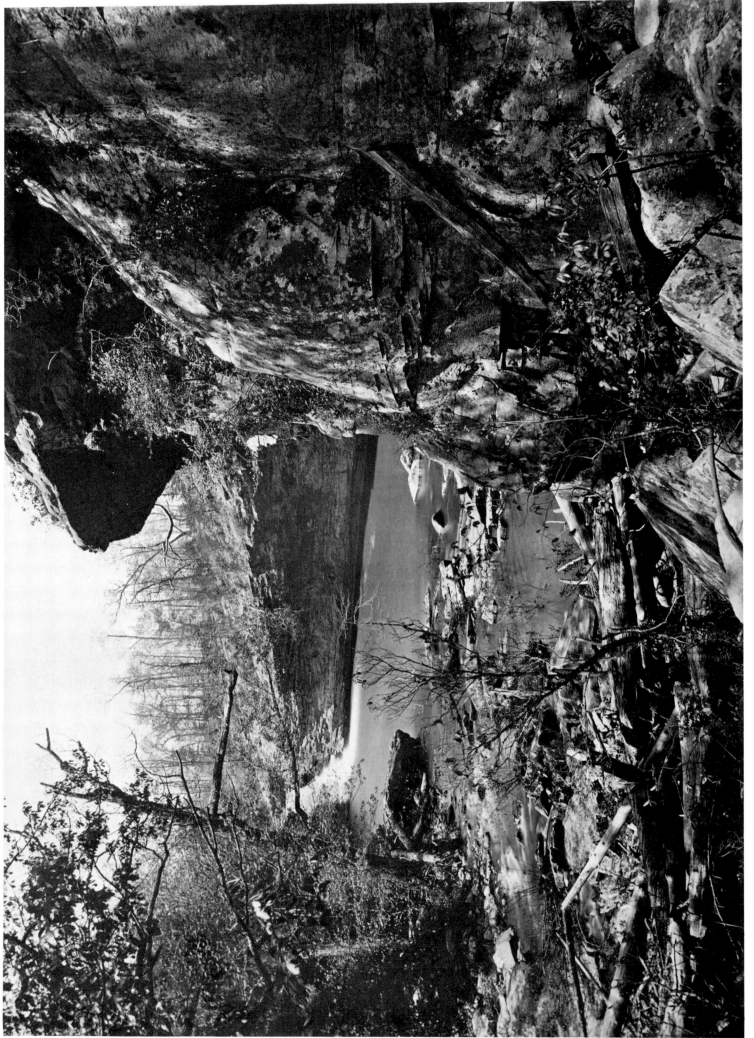

15 Lu-La Lake, Lookout Mountain

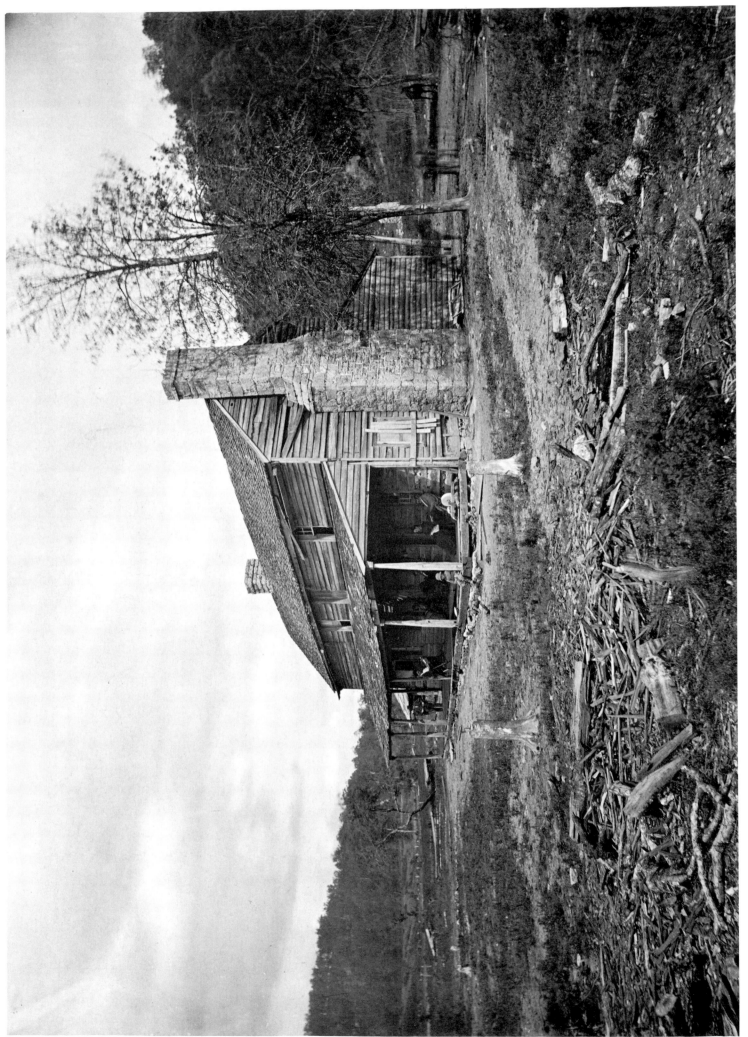

16 The John Ross House

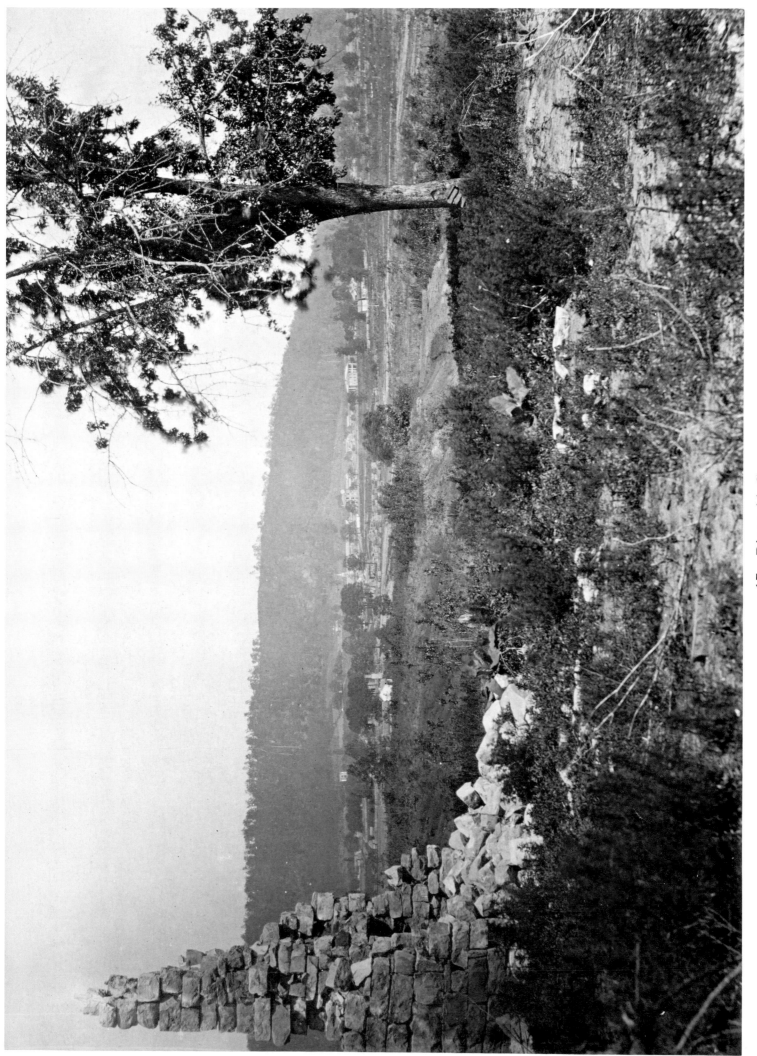

17 Ringgold, Ga.

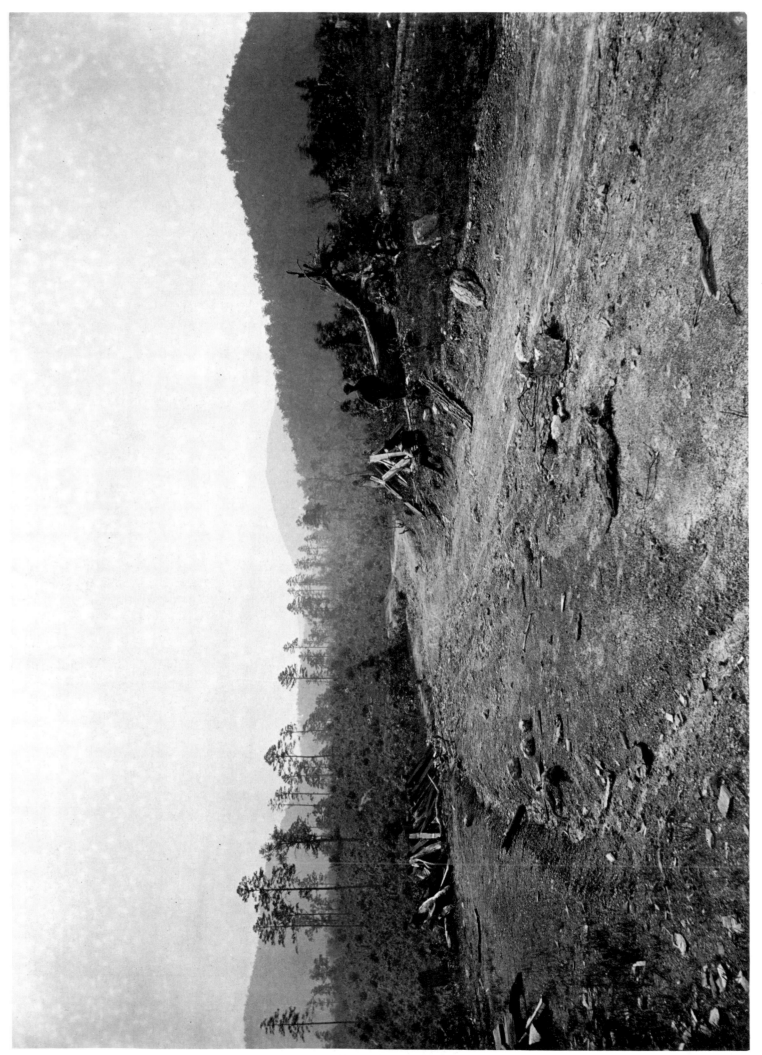

18 Buzzard-Roost. Gap, Ga.

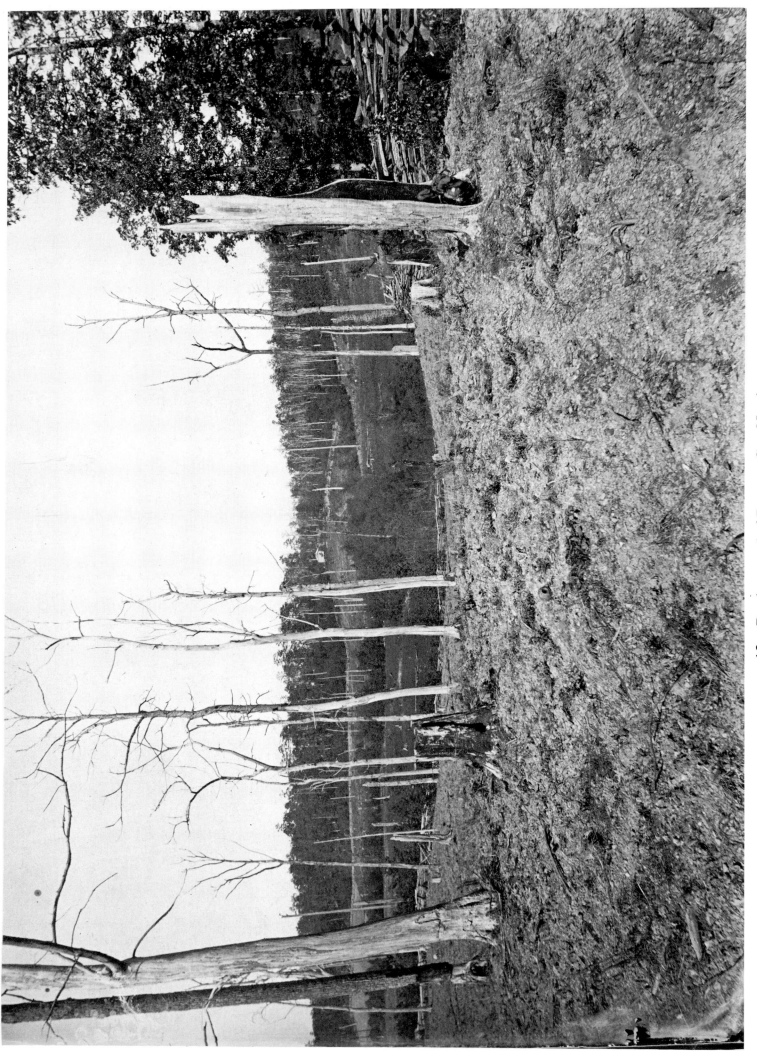

19 Battleground of Resaca, Ga., No. 1

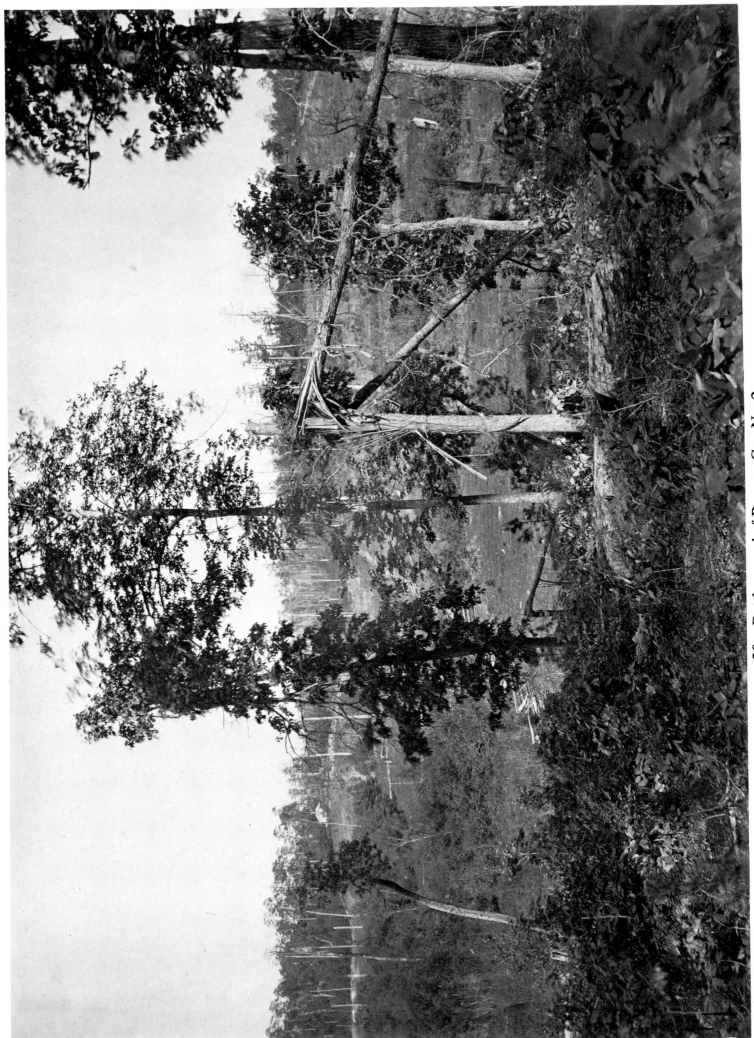

20 Battleground of Resaca, Ga., No. 2

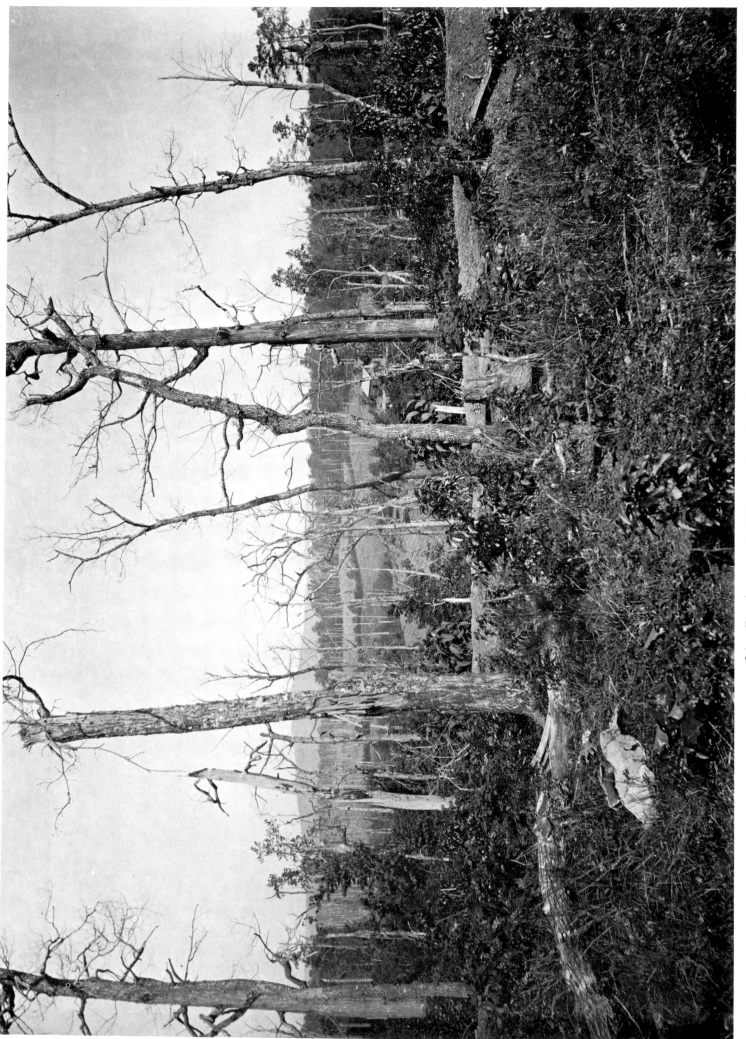

21 Battleground of Resaca, Ga., No. 3

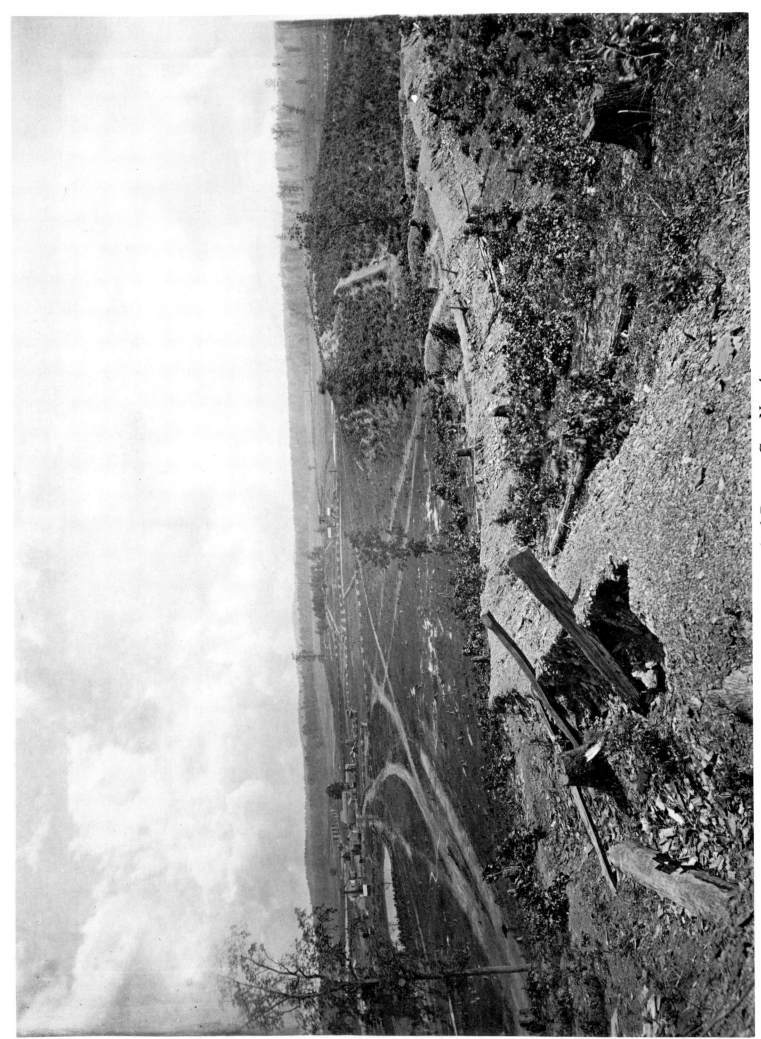

22 Battleground of Resaca, Ga., No. 4

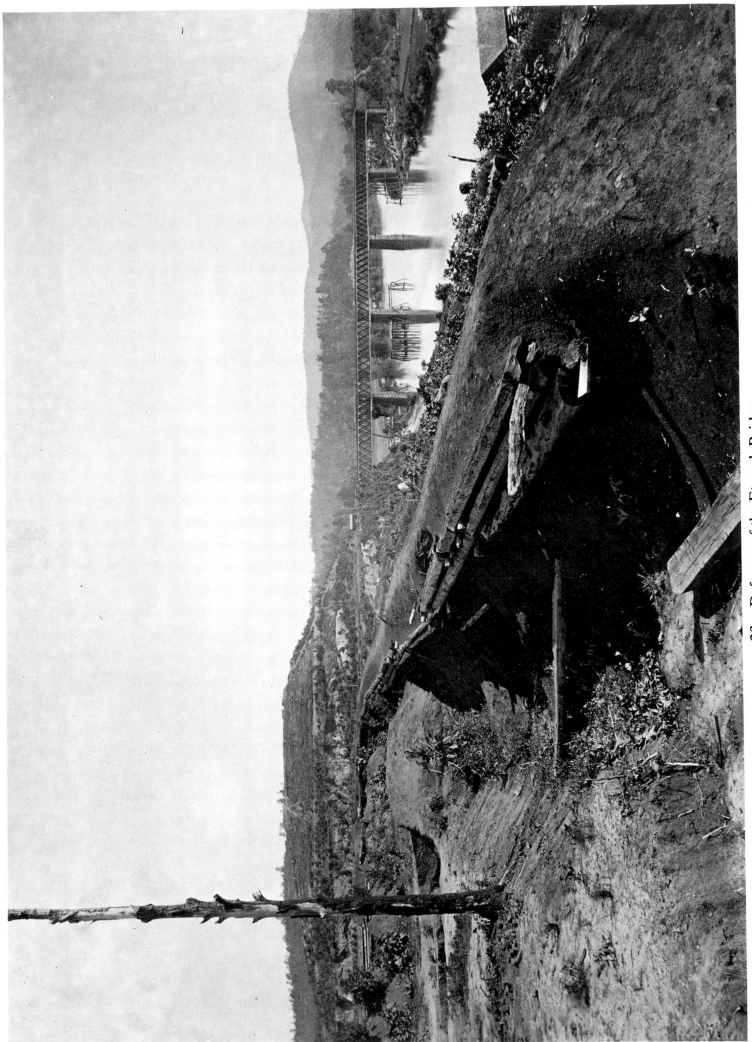

23 Defenses of the Etawah Bridge

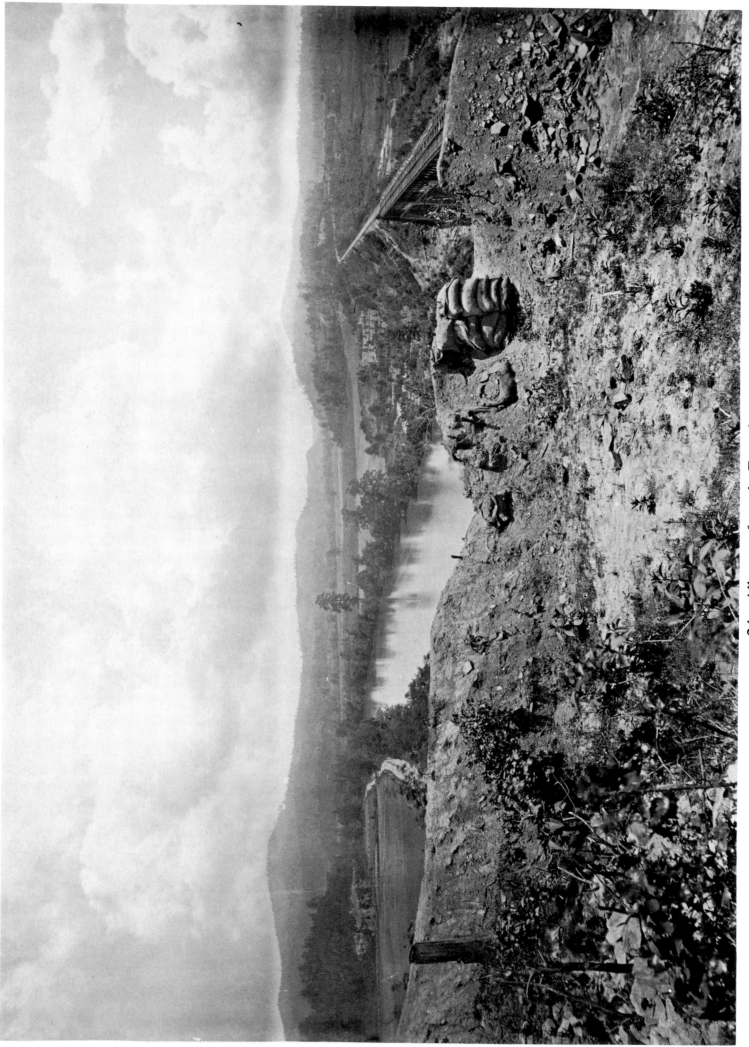

24 Allatoona from the Etawah

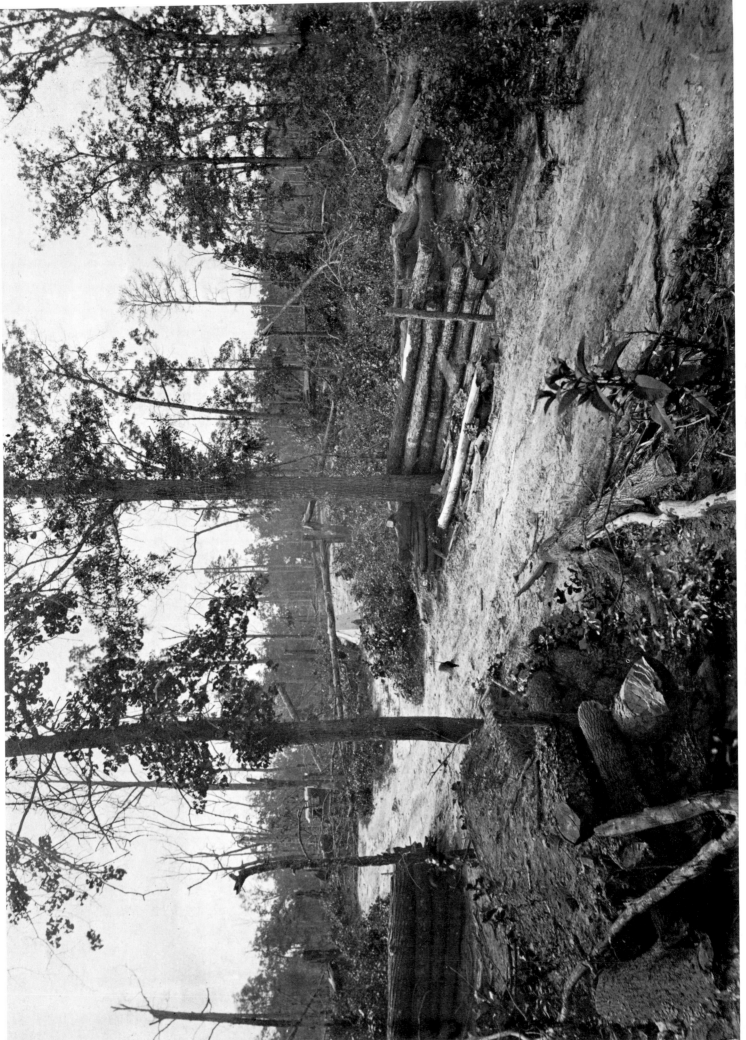

25 Battlefield of New Hope Church, Ga., No. 1

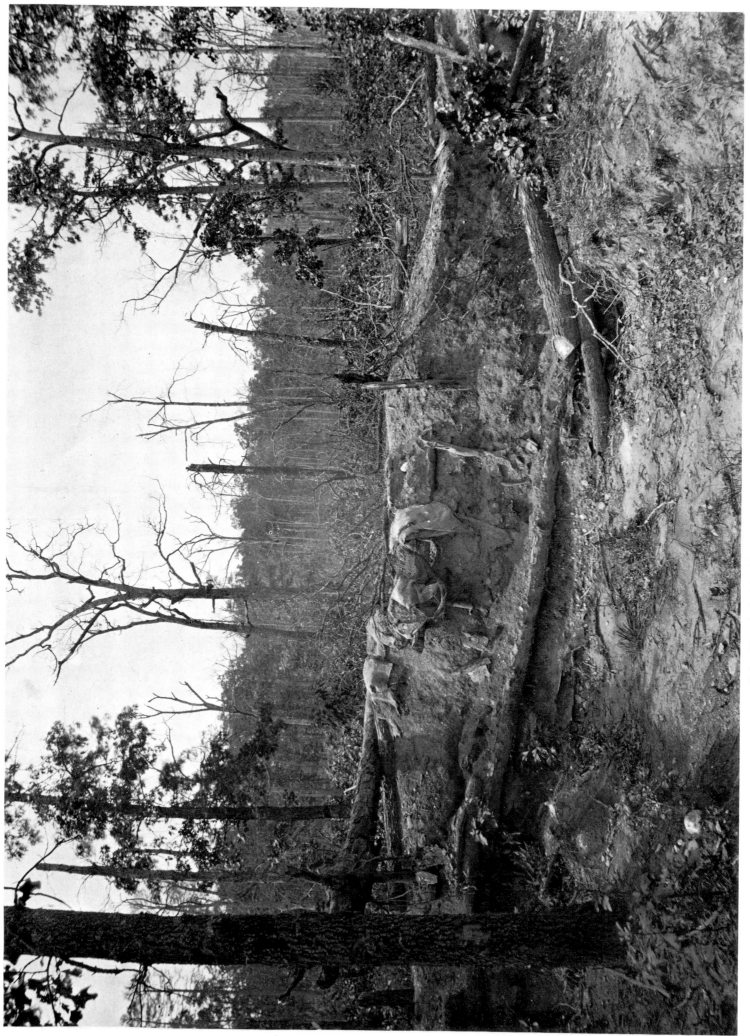

26 Battlefield of New Hope Church, Ga., No. 2

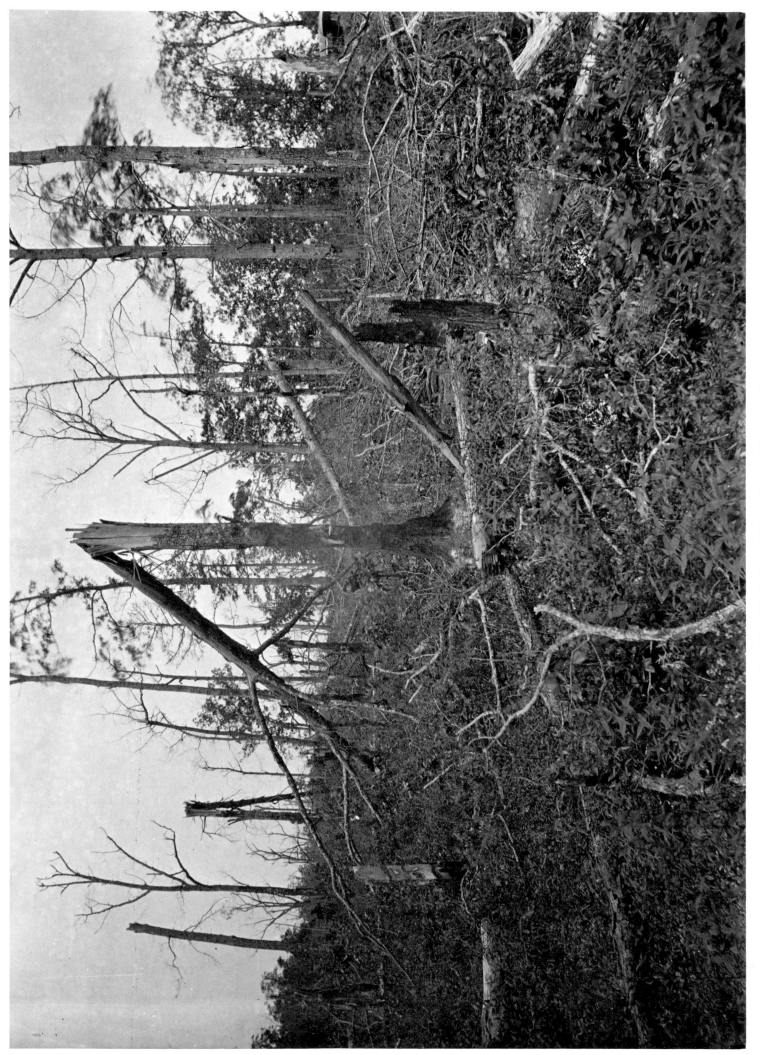

27 The "Hell Hole," New Hope Church, Ga.

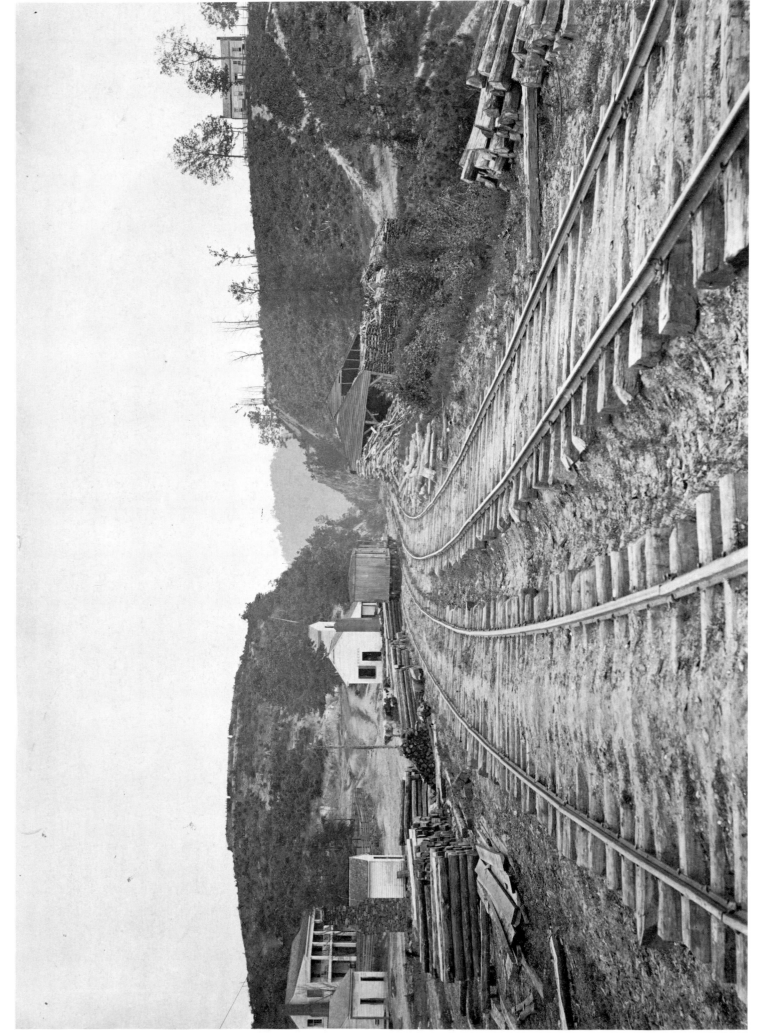

28 The Allatoona Pass, Looking North

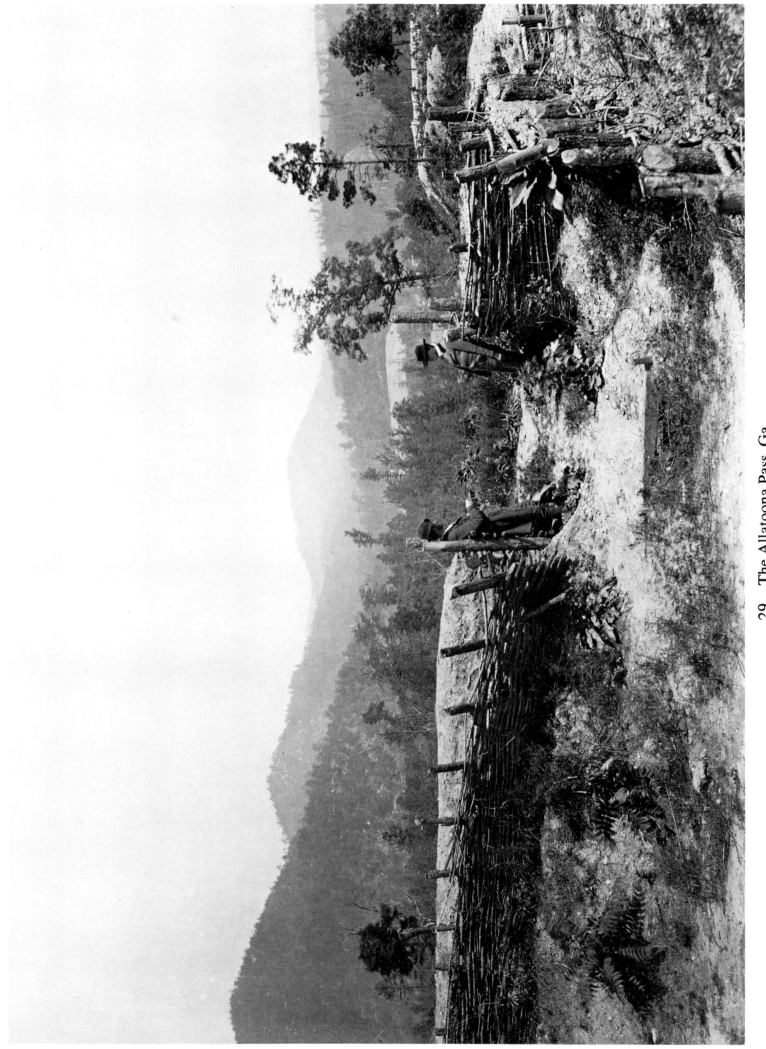

29　The Allatoona Pass, Ga.

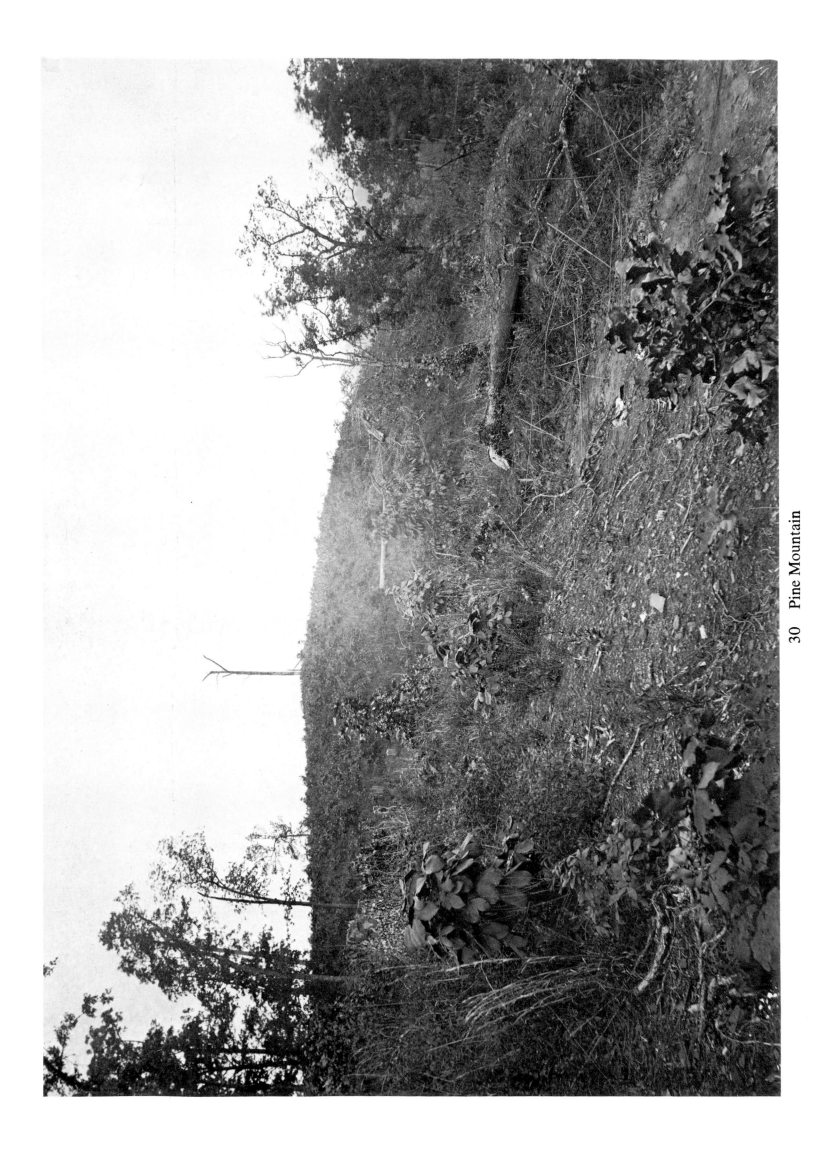

30 Pine Mountain

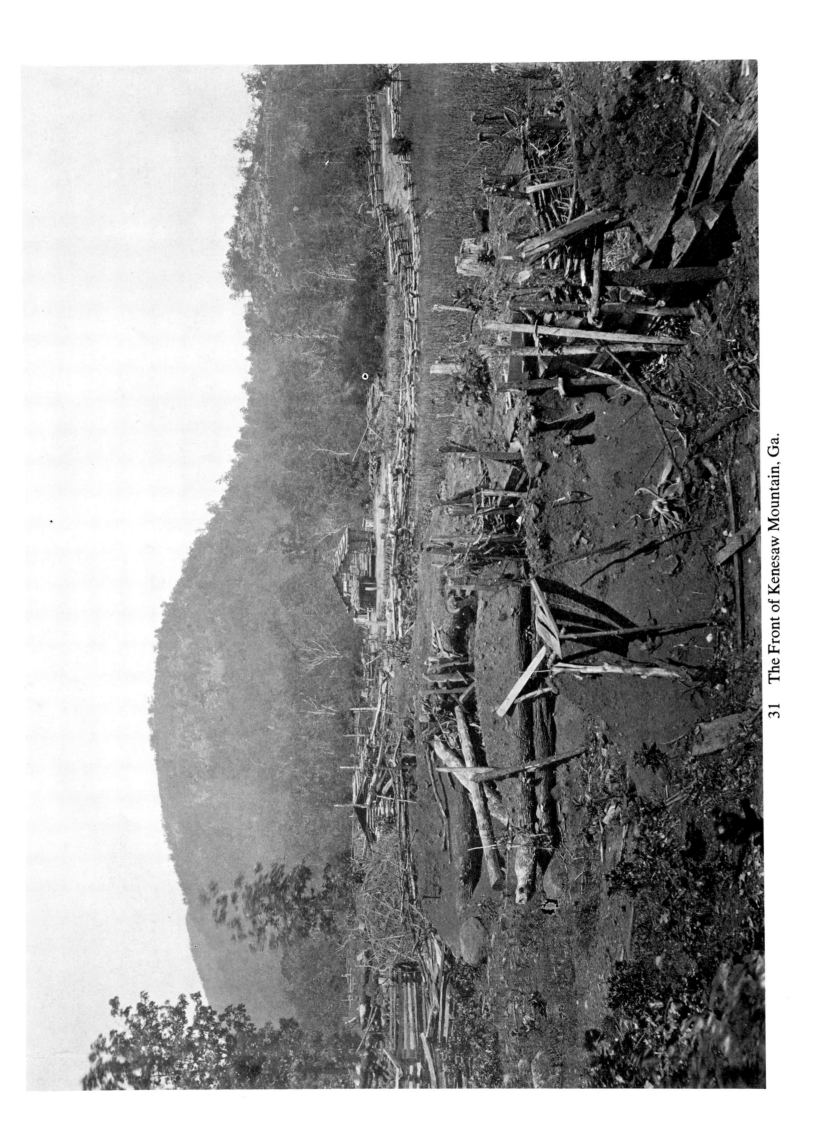

31 The Front of Kenesaw Mountain, Ga.

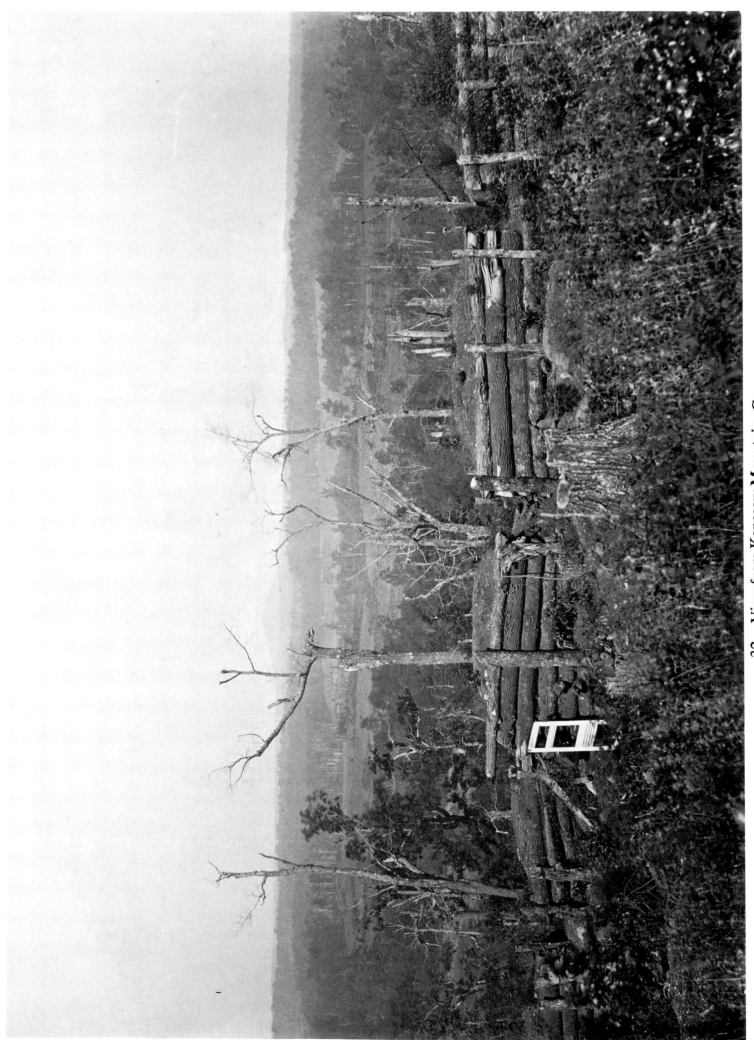

32 View from Kenesaw Mountain, Ga.

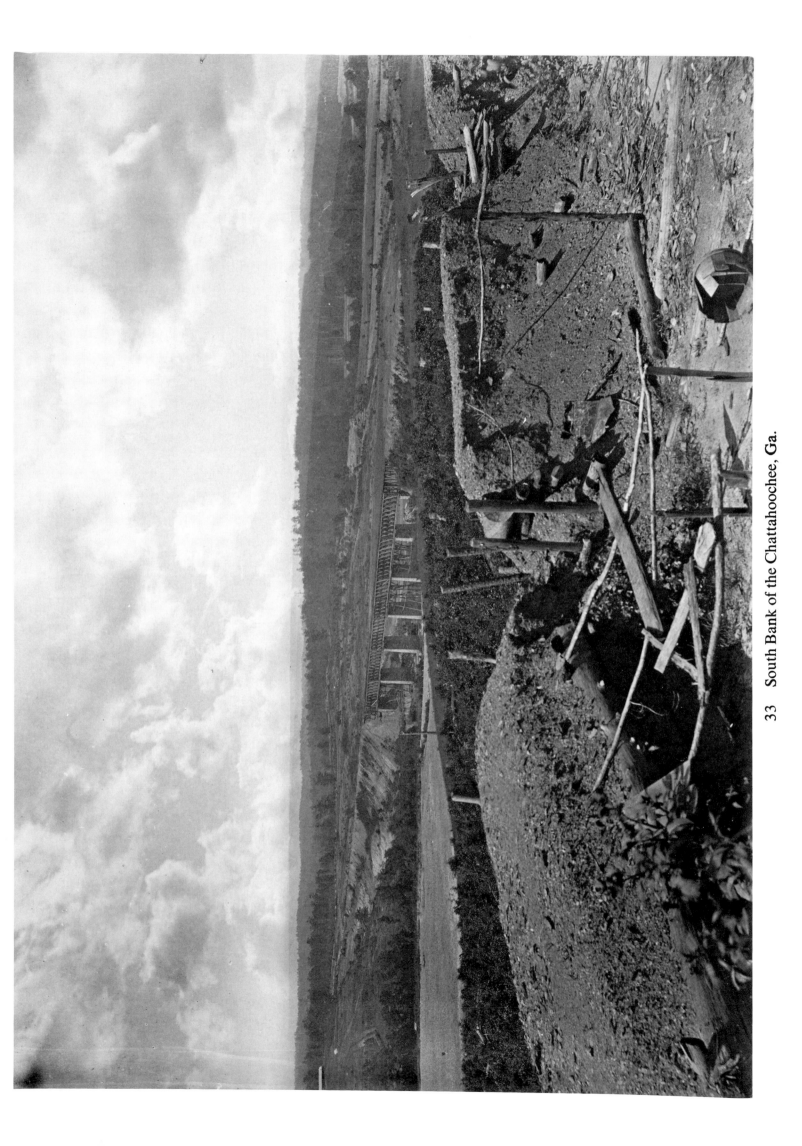

33 South Bank of the Chattahoochee, Ga.

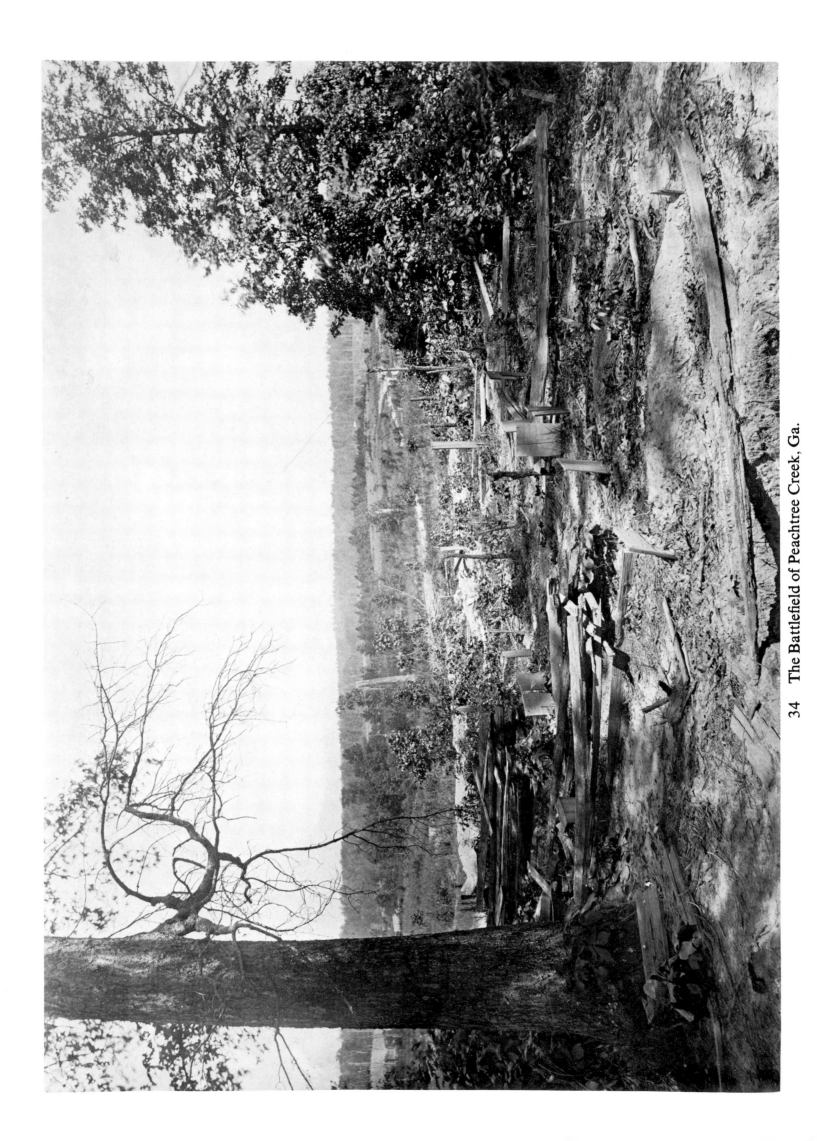

34 The Battlefield of Peachtree Creek, Ga.

35 Scene of Gen. McPherson's Death

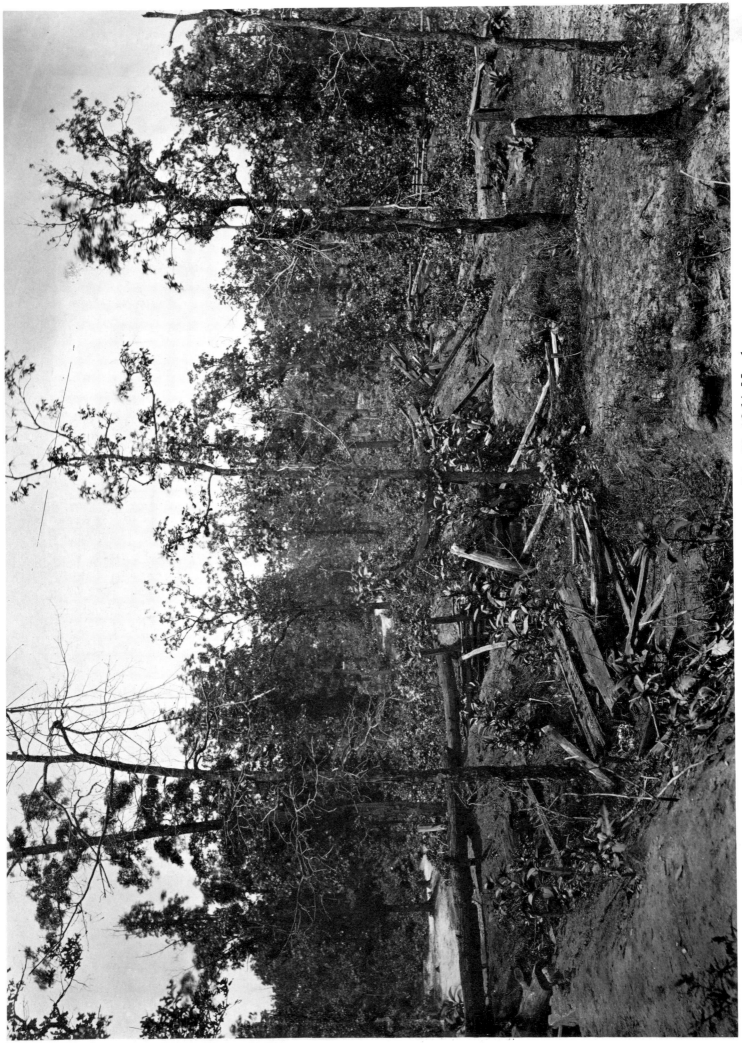

36 Battlefield of Atlanta, Ga., July 22, 1864, No. 1

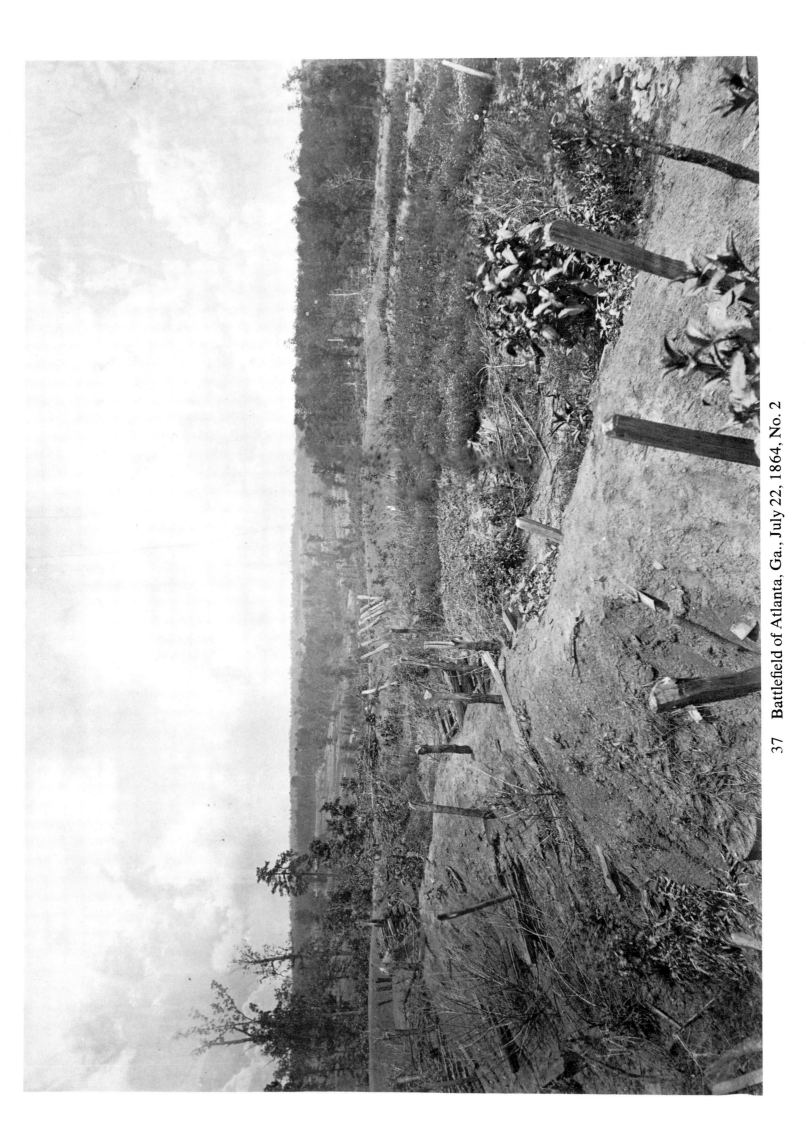

37 Battlefield of Atlanta, Ga., July 22, 1864, No. 2

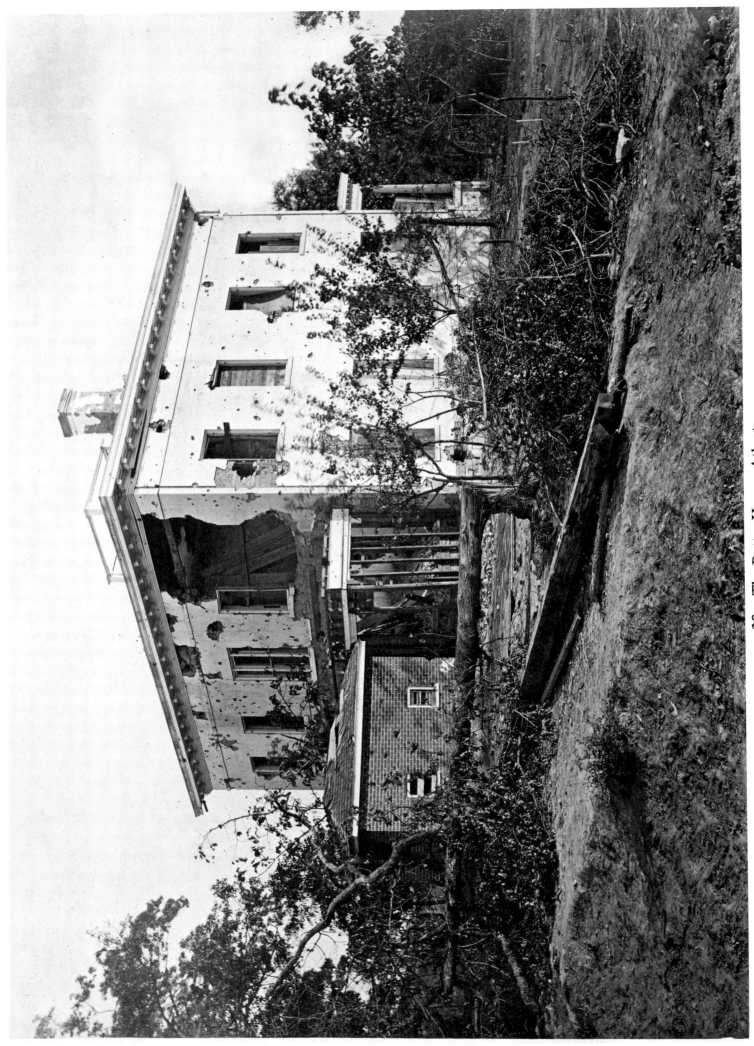

38 The Potter House, Atlanta

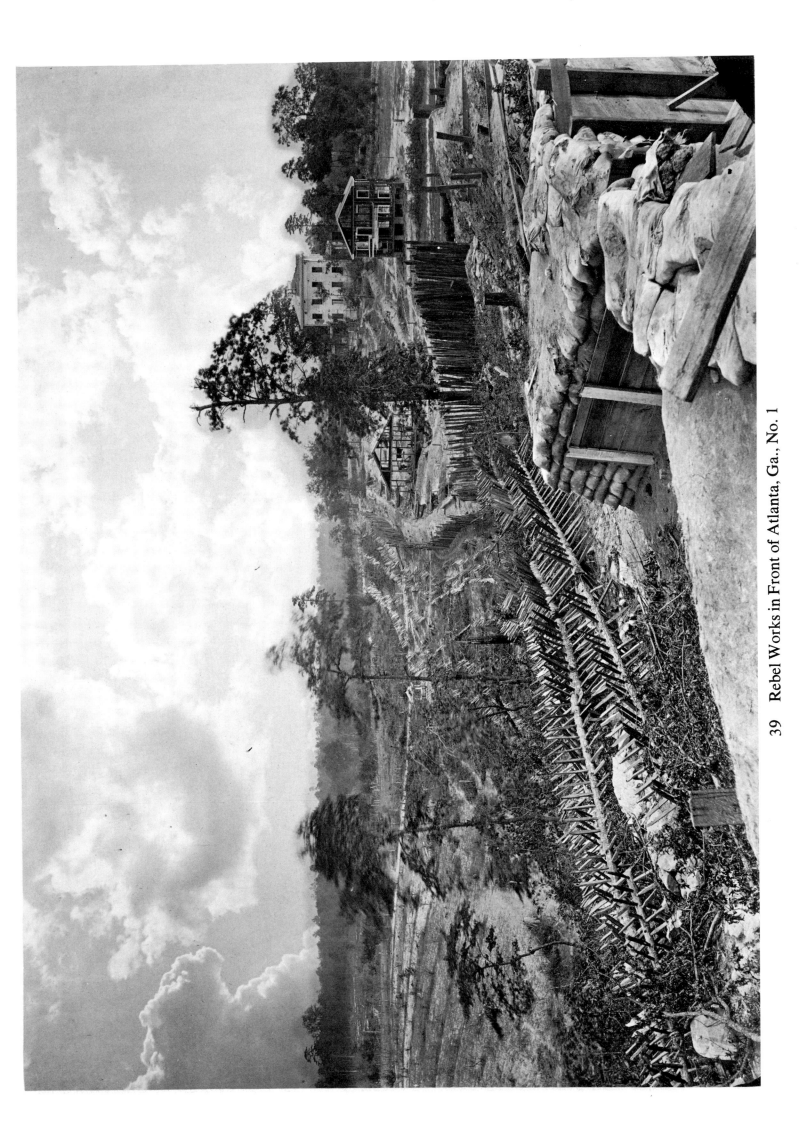

39 Rebel Works in Front of Atlanta, Ga., No. 1

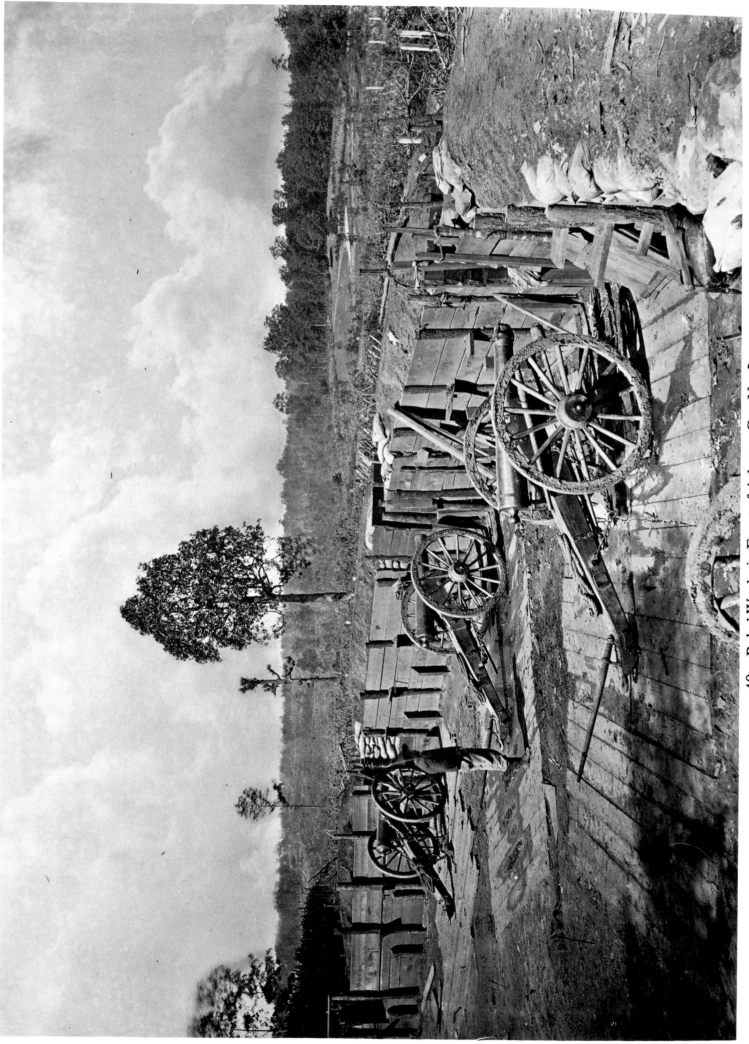

40 Rebel Works in Front of Atlanta, Ga., No. 2

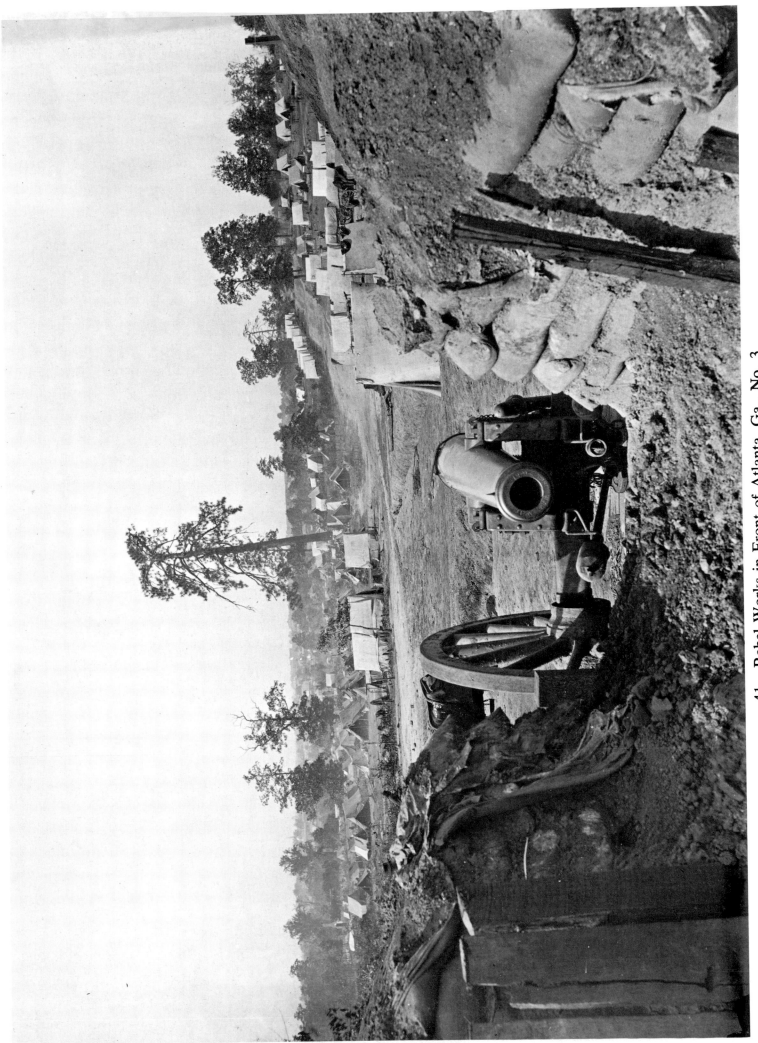

41 Rebel Works in Front of Atlanta, Ga., No. 3

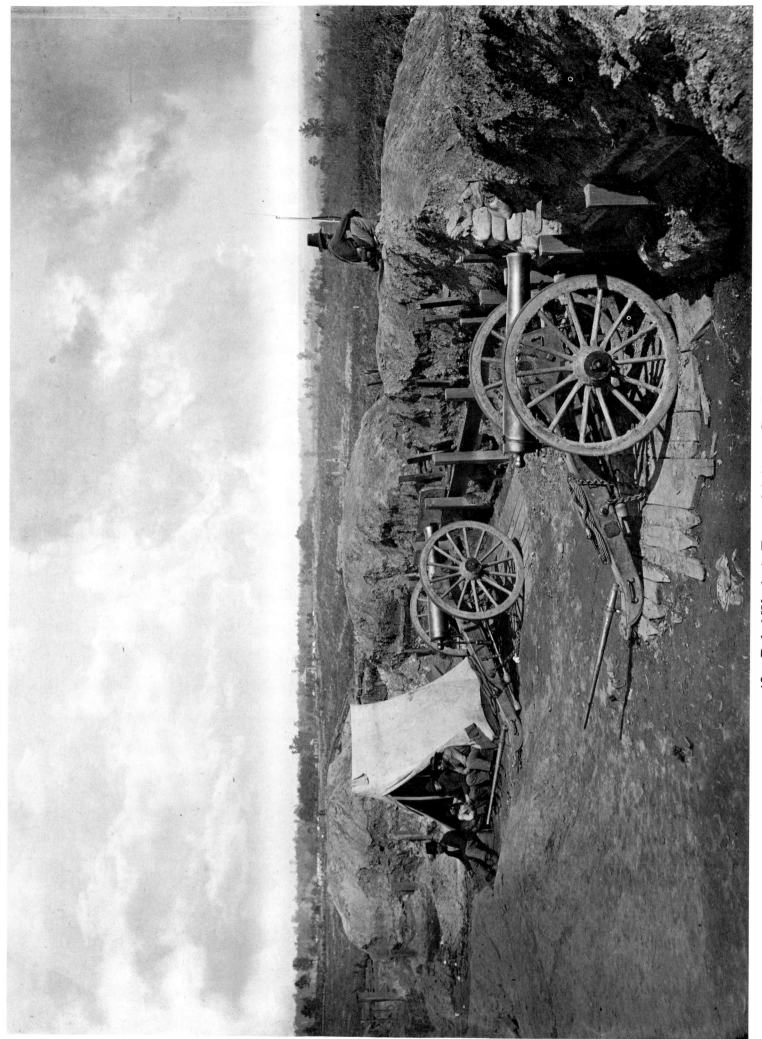

42 Rebel Works in Front of Atlanta, Ga., No. 4

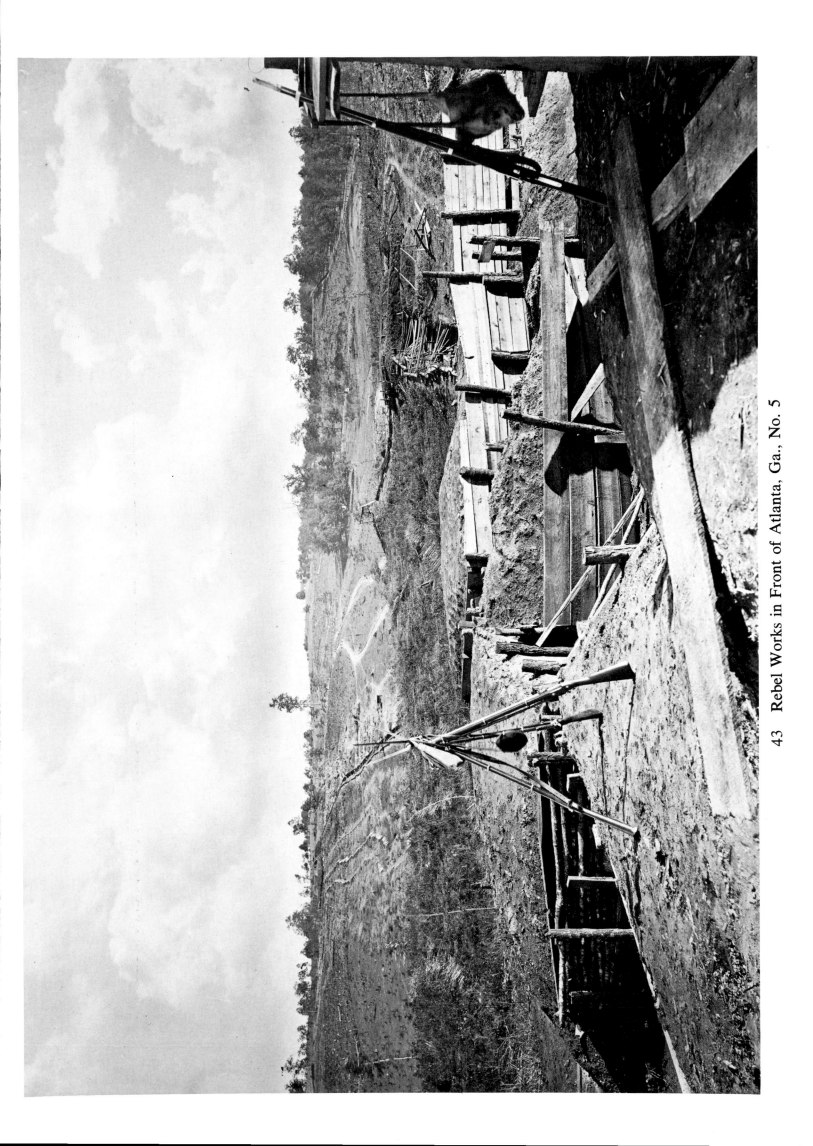

43 Rebel Works in Front of Atlanta, Ga., No. 5

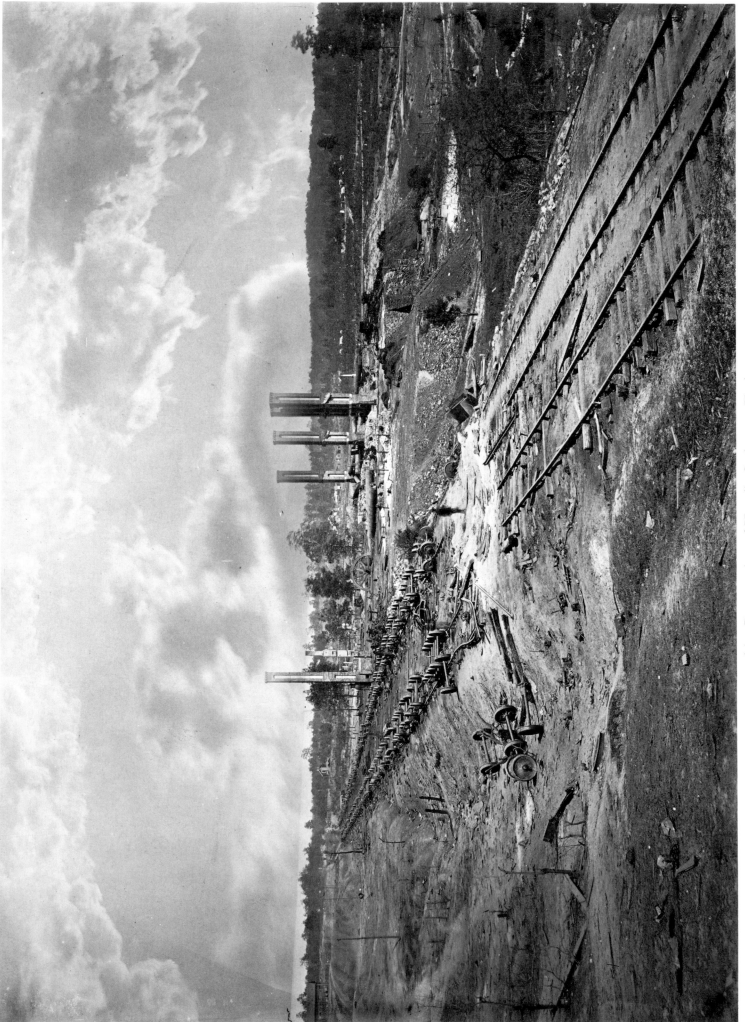

44 Destruction of Hood's Ordnance Train

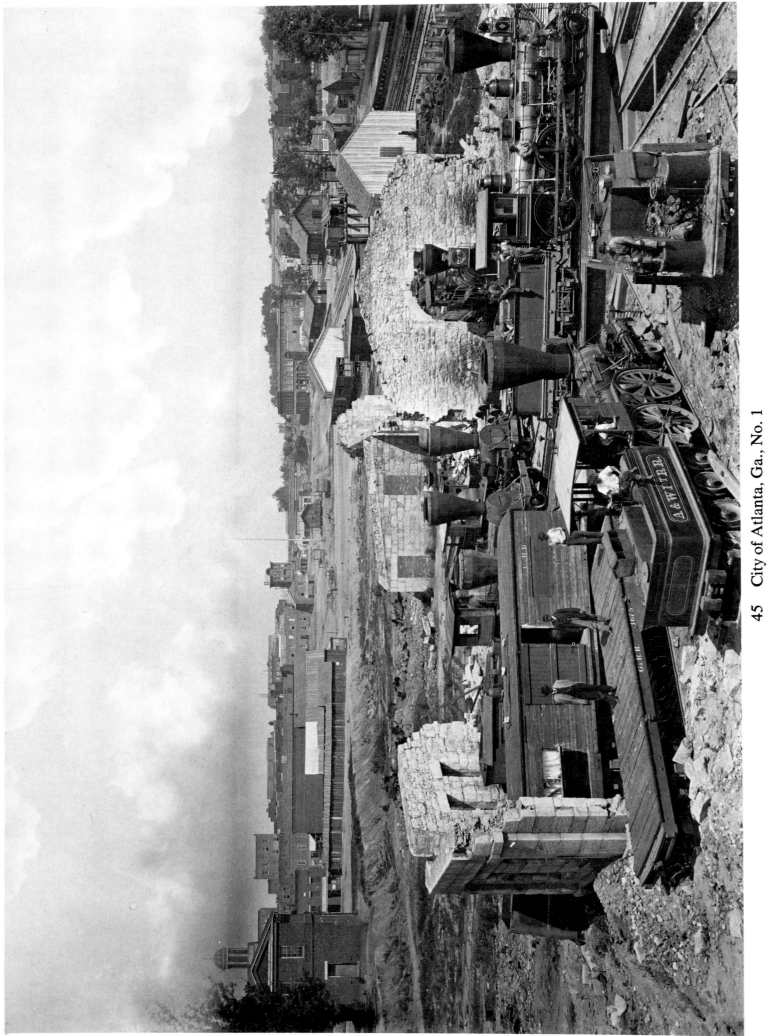

45 City of Atlanta, Ga., No. 1

46 City of Atlanta, Ga., No. 2

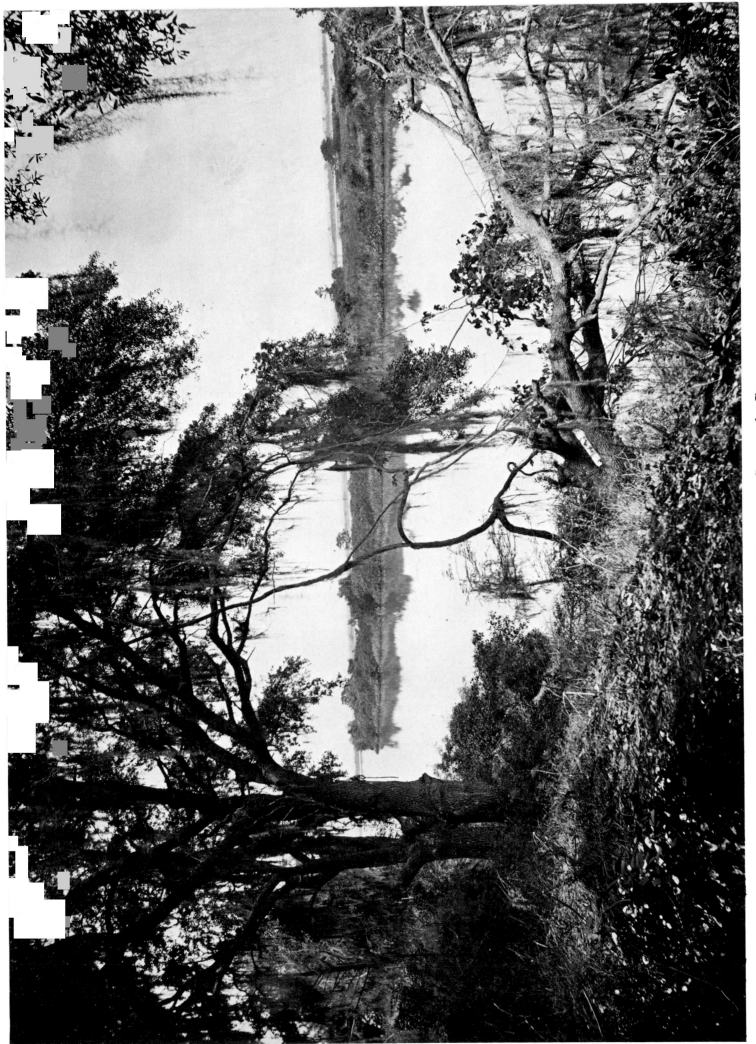

47 Savannah River, near Savannah, Ga.

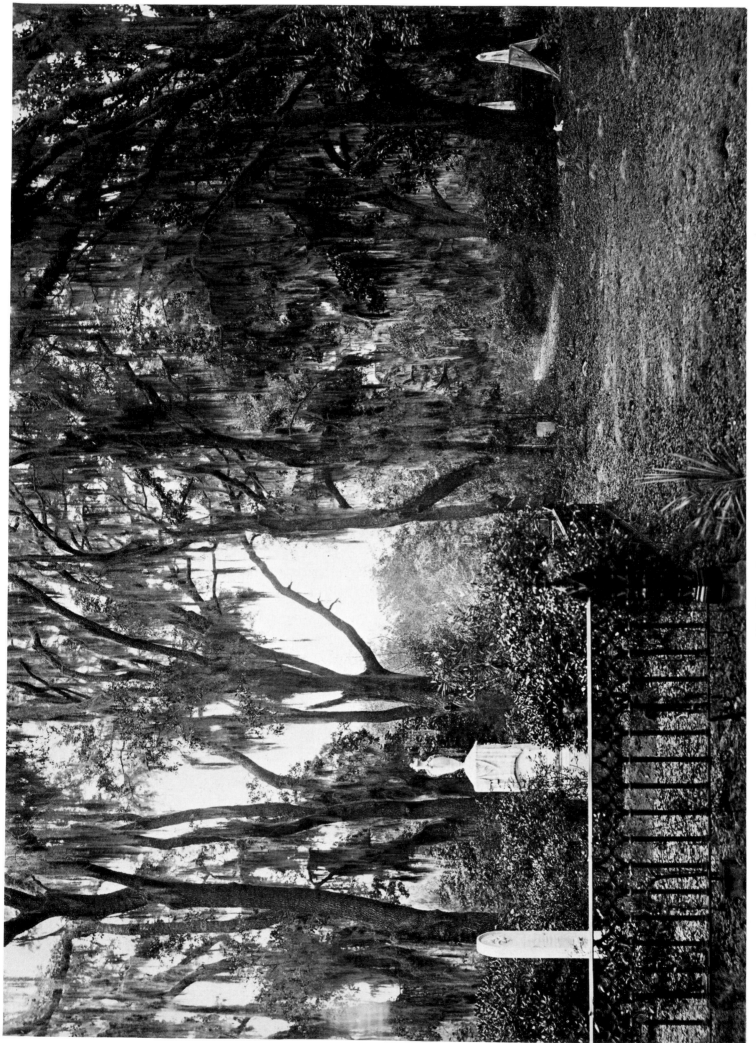

48　Buen-Ventura, Savannah, Ga.

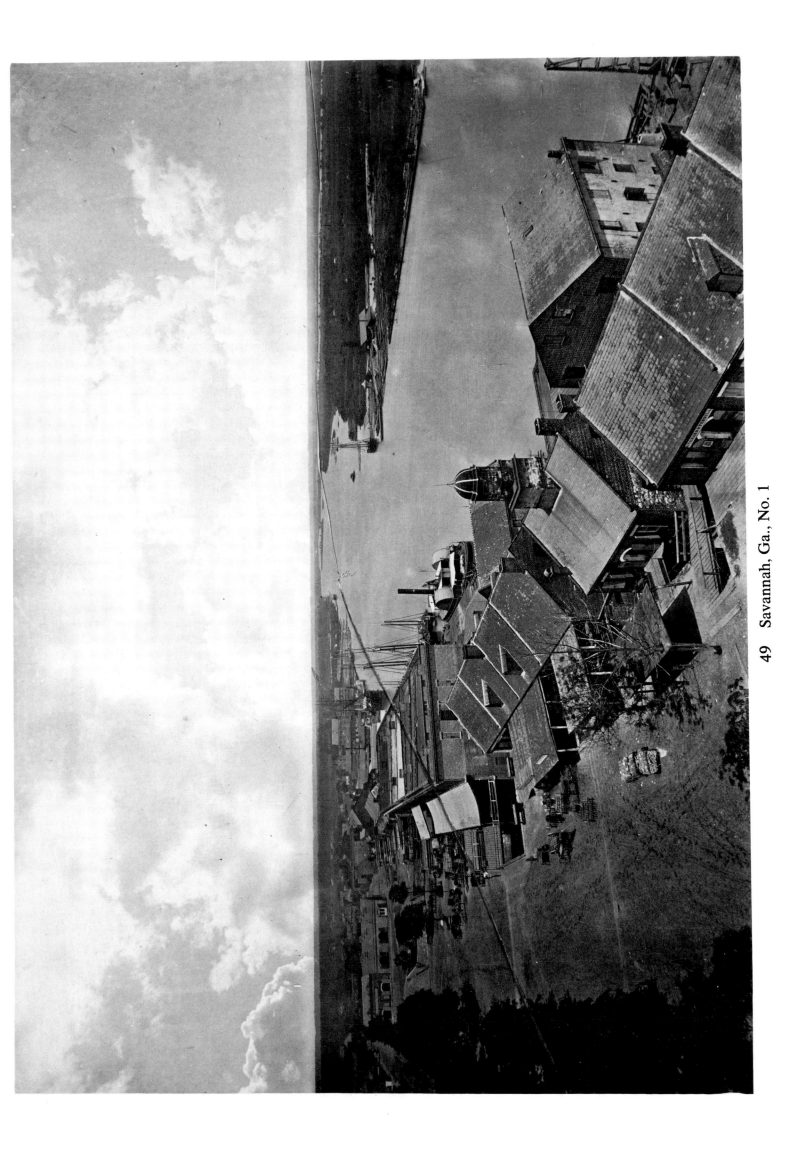

49 Savannah, Ga., No. 1

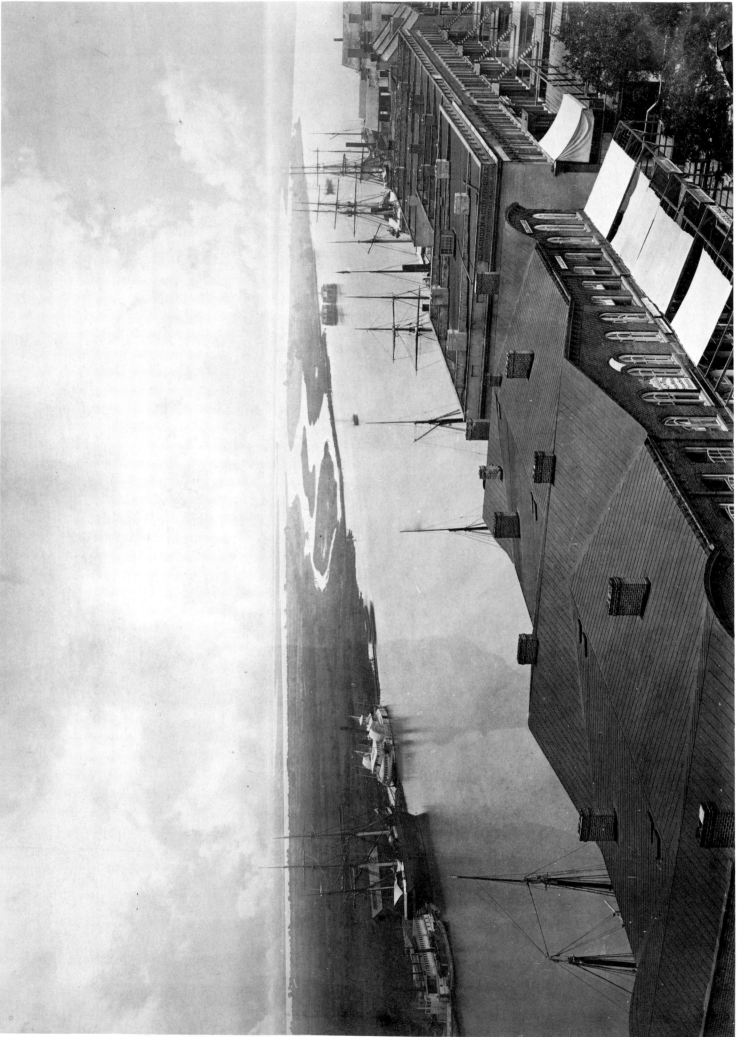

50 Savannah, Ga., No. 2

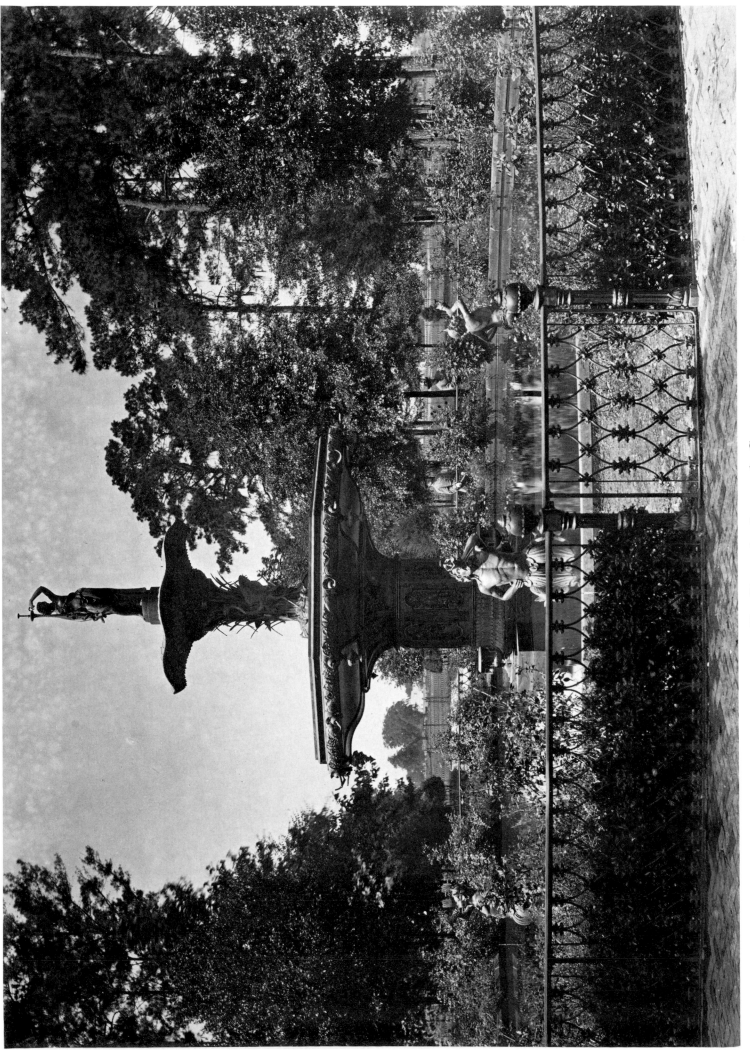

51 Fountain, Savannah, Ga.

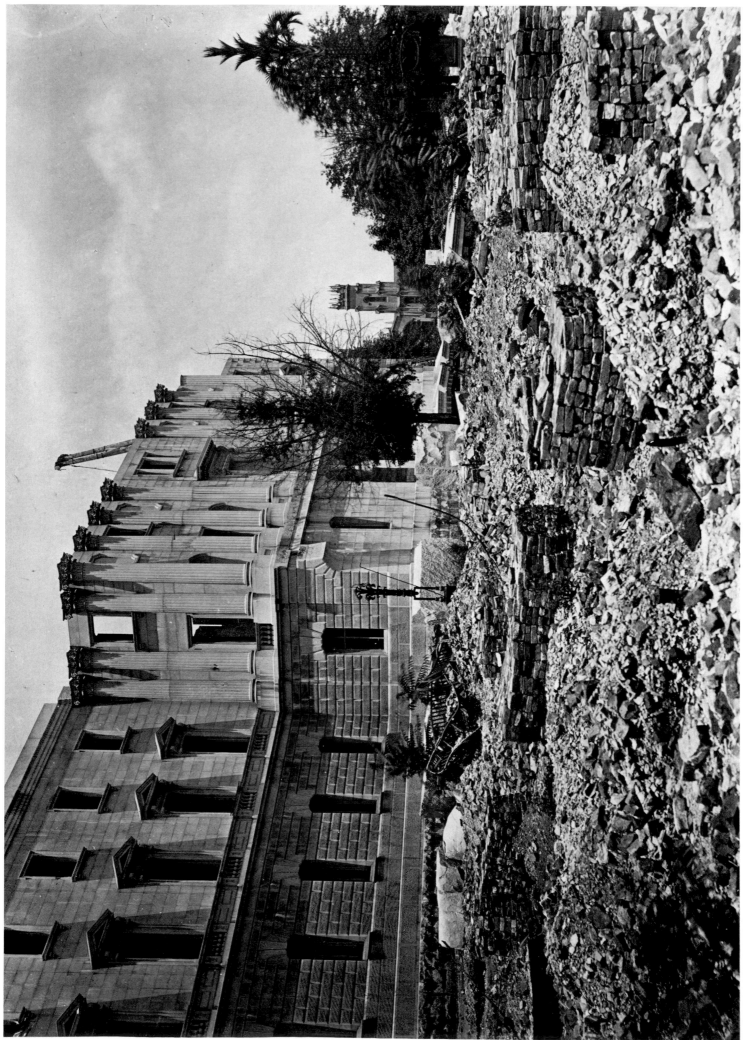

52 The New Capitol, Columbia, S. C.

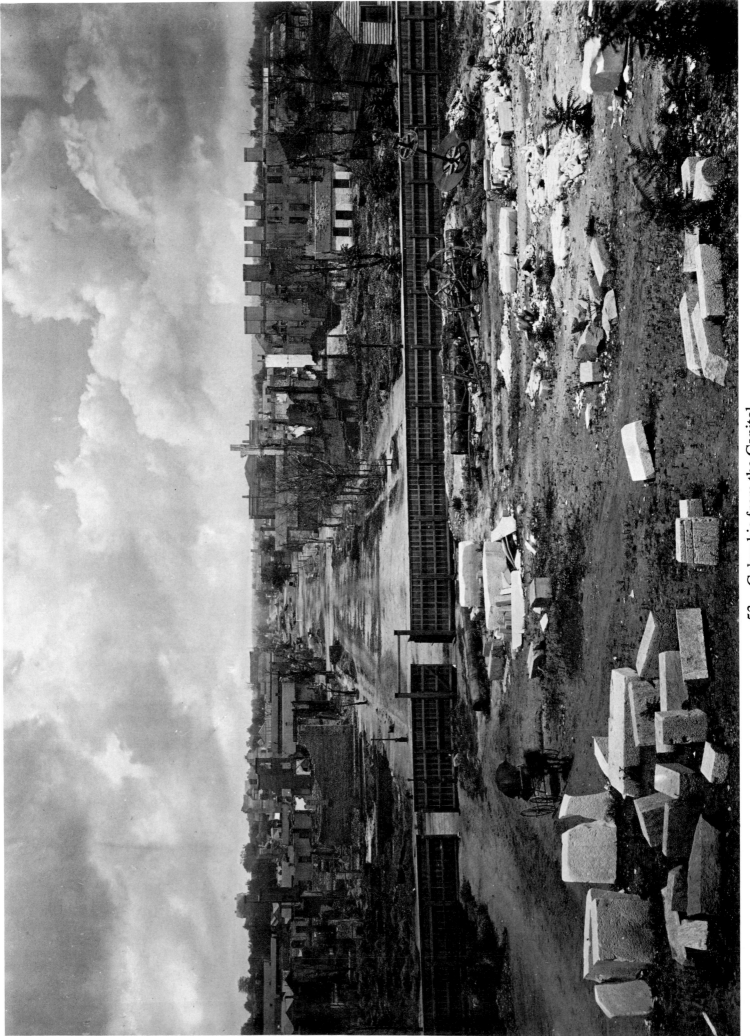

53 Columbia from the Capitol

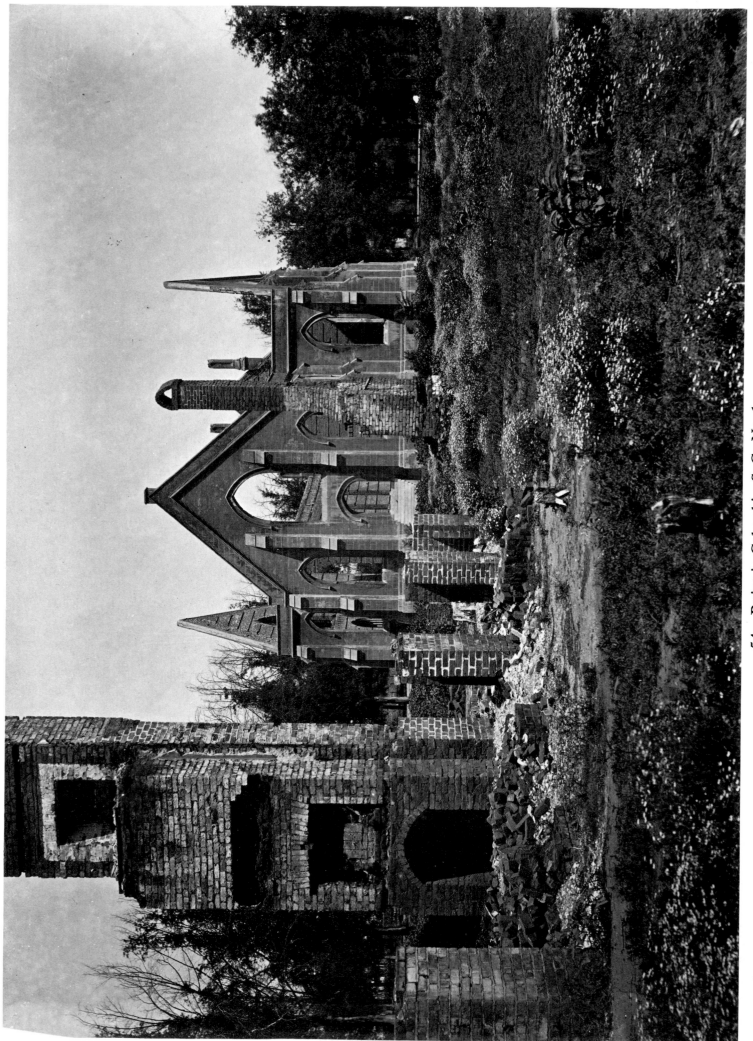

54 Ruins in Columbia, S. C., No. 1

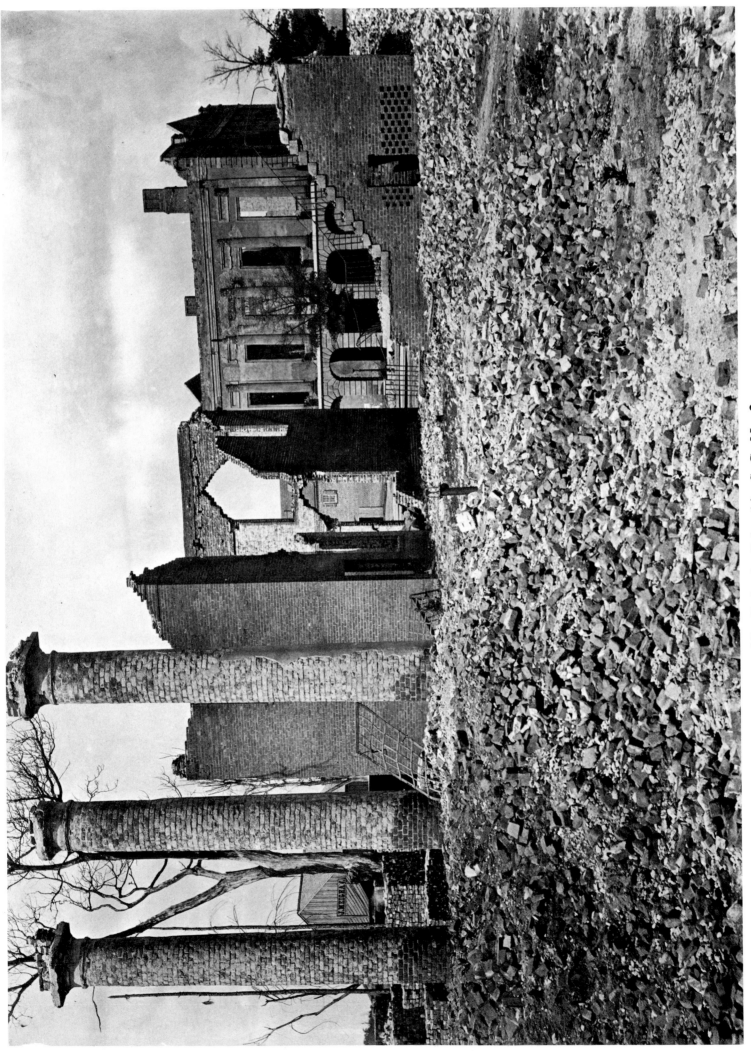

55 Ruins in Columbia, S. C., No. 2

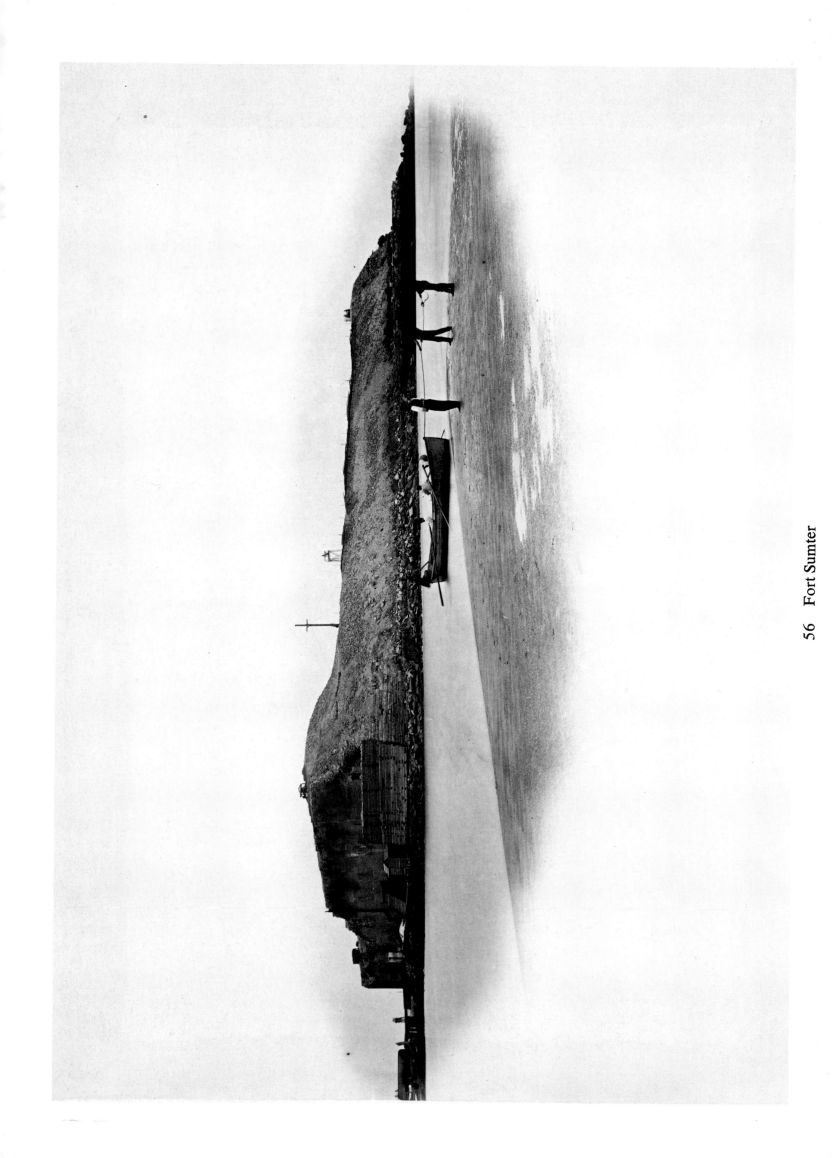

56 Fort Sumter

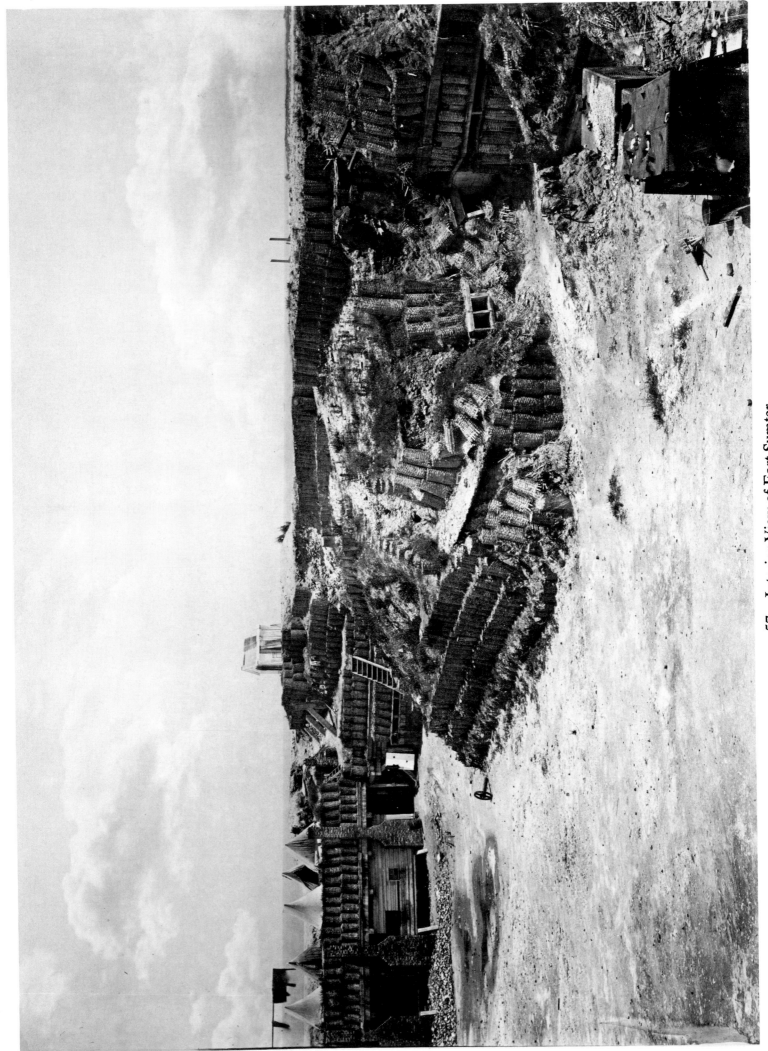

57 Interior View of Fort Sumter

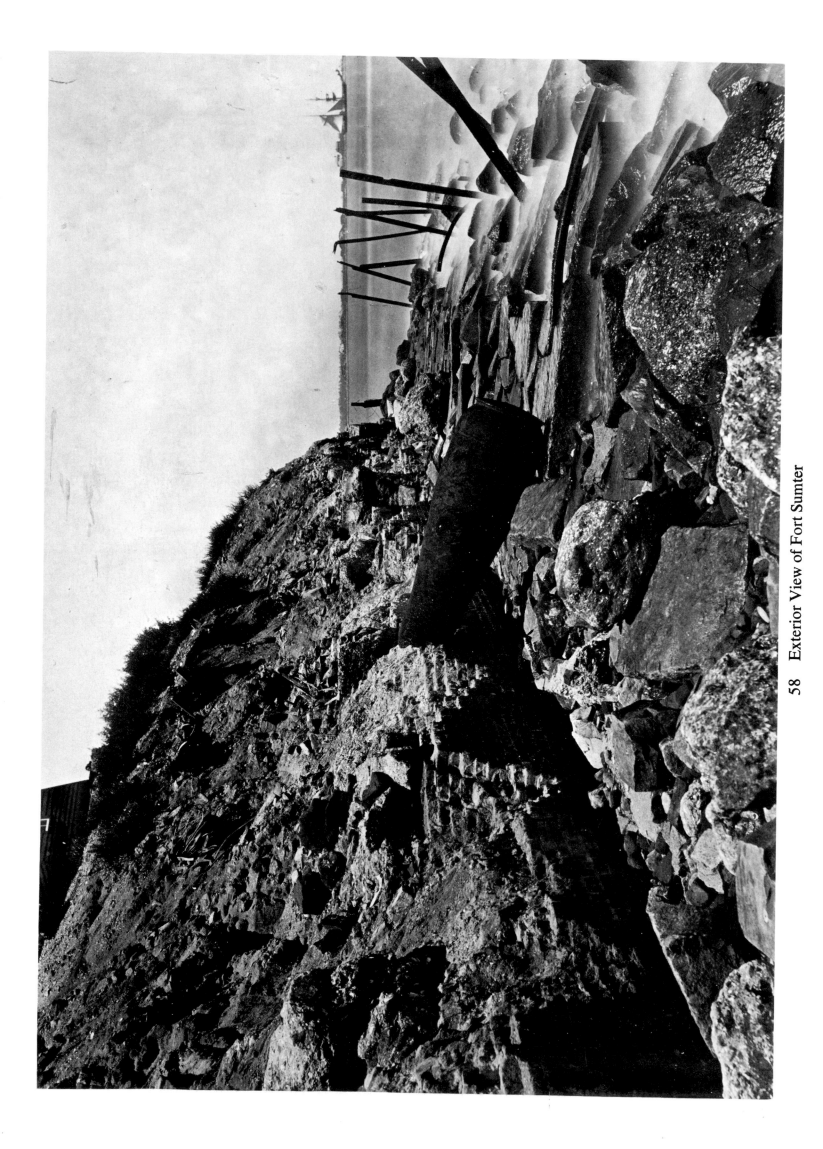

58 Exterior View of Fort Sumter

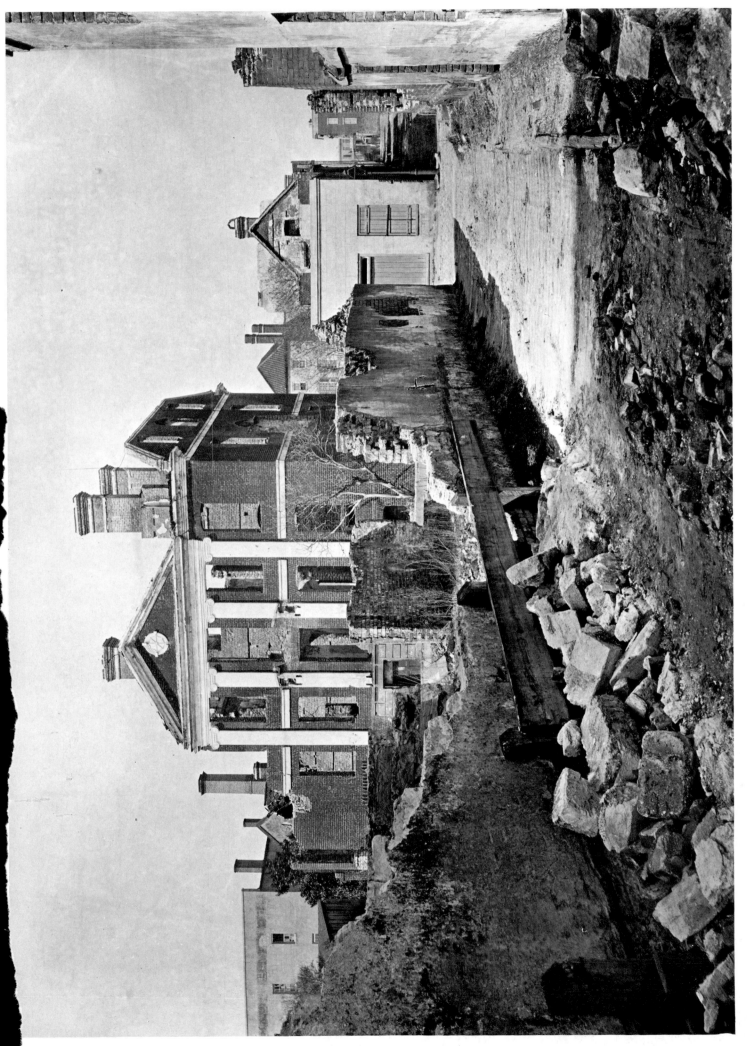

59 Ruins of the Pinckney Mansion, Charleston, S. C.

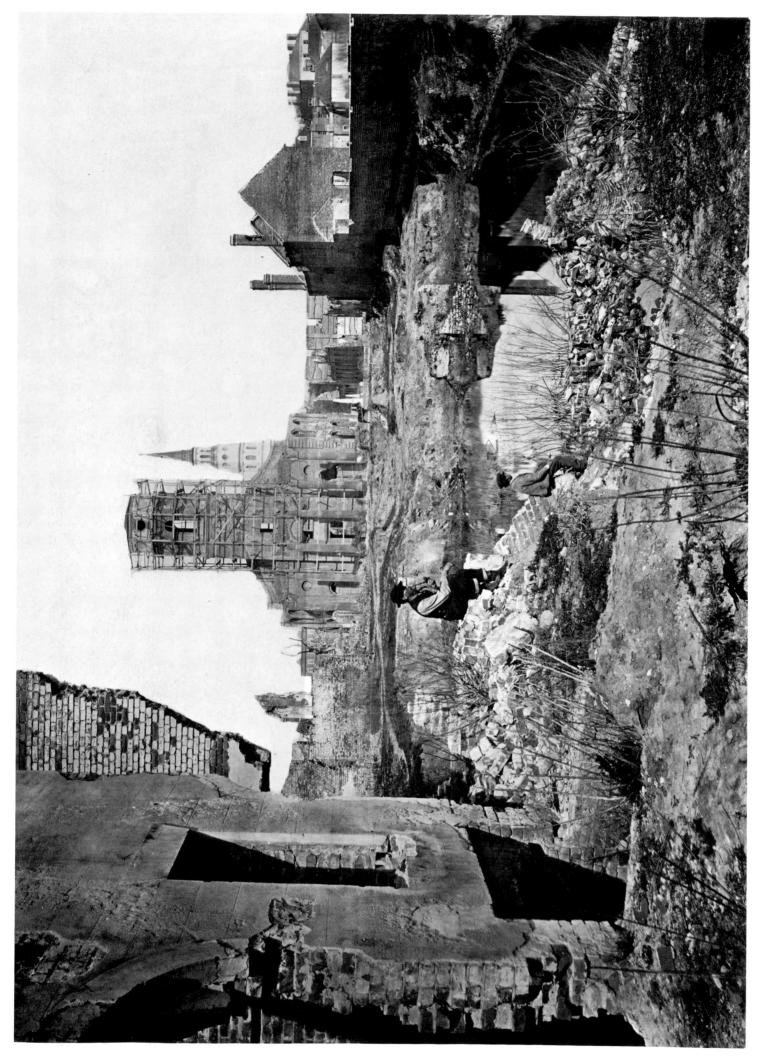

60 Ruins in Charleston, S. C.

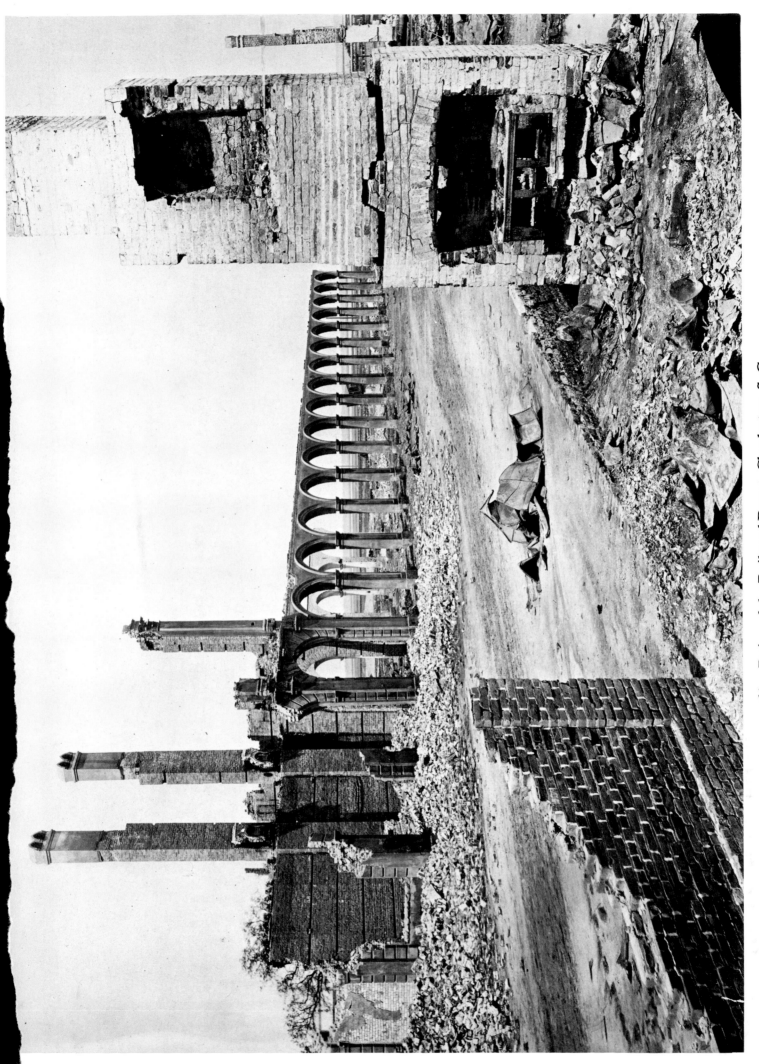

61 Ruins of the Railroad Depot, Charleston, S. C.